Remembering Montana

Gary Glenn

TURNER
PUBLISHING COMPANY

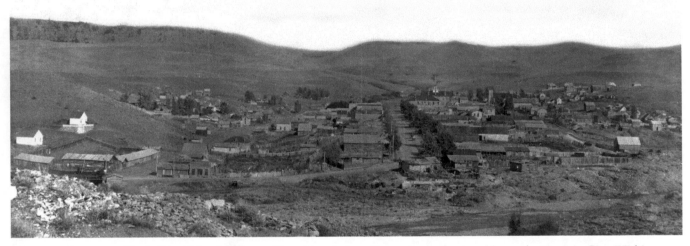

The 1863 discovery of "color" in Alder Gulch set off a gold rush from Bannack to what would soon be Virginia City. Within two years Virginia City had become the territorial capital and boasted a population in the thousands. Seen here near the end of the nineteenth century, Virginia city today is a popular Old West tourist destination.

Remembering
Montana

Turner Publishing Company
4507 Charlotte Avenue • Suite 100
Nashville, Tennessee 37209
(615) 255-2665

Remembering Montana

www.turnerpublishing.com

Copyright © 2010 Turner Publishing Company

Library of Congress Control Number: 2010932280

ISBN: 978-1-59652-707-2

Printed in the United States of America

ISBN: 978-1-68336-857-1 (pbk)

CONTENTS

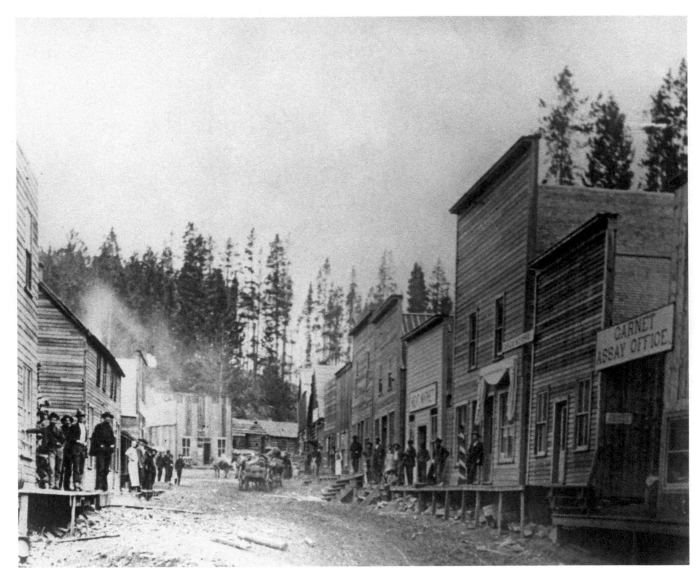

Seen here in its heyday around 1895, Garnet today is one of Montana's best-preserved ghost towns. The district's 50 mines produced almost $10 million in precious metals between 1862 and 1916. The Garnet Preservation Association has been instrumental in protecting much of the town.

Acknowledgments

This volume, *Remembering Montana,* is the result of the cooperation and effort of many individuals, organizations, and corporations. It is with great thanks that we acknowledge the valuable contribution of the following for their generous support:

Mansfield Library, Archives and Special Collections, The University of Montana-Missoula
The Historical Museum at Fort Missoula
Library of Congress
Amy Casamassa, Mansfield Library
Mark Fritch, Mansfield Library

The writer would like to thank Daniel Cooper of Turner Publishing for his cogent editing; Dale Johnson, former archivist at the Mansfield Library, for Hallways to History; and all the photographers, professional and amateur, known and unknown, who preserved the history of the Treasure State on film. Of special note are R. H. McKay, who faithfully chronicled the landscapes of western Montana, Edward Curtis, who obsessively recorded the culture of the American Indian, and photojournalist Stan Healy, who roamed the gritty streets of downtown Missoula with camera in hand.

The contributions of Mary Lyndes, Kelsey Glynn, and Connor Glynn made this book possible.

PREFACE

Montana has thousands of historic photographs that reside in archives, both locally and nationally. This book began with the observation that, while those photographs are of great interest to many, they are not easily accessible. During a time when Montana is looking ahead and evaluating its future course, many people are asking, How do we treat the past? These decisions affect every aspect of the state—architecture, public spaces, commerce, infrastructure—and these, in turn, affect the way that people live their lives. This book seeks to provide easy access to valuable, objective look into the history of Montana.

The power of photographs is that they are less subjective than words in their treatment of history. Although the photographer can make subjective decisions regarding subject matter and how to capture and present it, photographs seldom interpret the past to the extent textual histories can. For this reason, photography is uniquely positioned to offer an original, untainted look at the past, allowing the viewer to learn for himself what the world was like a century or more ago.

This project represents countless hours of review and research. The researchers and writer have reviewed thousands of photographs in numerous archives. We greatly appreciate the generous assistance of the archivists listed in the acknowledgments of this work, without whom this project could not have been completed.

The goal in publishing this work is to provide broader access to sets of extraordinary photographs that seek to inspire, provide perspective, and evoke insight that might assist people who are responsible for determining Montana's future. In addition, the book seeks to preserve the past with adequate respect and reverence.

With the exception of touching up imperfections that have accrued with the passage of time and cropping where necessary, no changes have been made. The focus and clarity of many images are limited to the technology and the ability of the photographer at the time they were recorded.

The work is divided into eras. Beginning with some of the earliest known photographs of Montana, the

first section records photographs through the end of the nineteenth century. The second section spans the beginning of the twentieth century through World War I. Section Three moves from the 1920s to the end of the Great Depression. The last section covers the World War II years.

In each of these sections we have made an effort to capture various aspects of life through our selection of photographs. People, commerce, transportation, infrastructure, religious institutions, and educational institutions have been included to provide a broad perspective.

We encourage readers to reflect as they go walking in Montana, strolling through its parks, its countryside, and the neighborhoods of its cities. It is the publisher's hope that in uitilizing this work, longtime residents will learn something new and that new residents will gain a perspective on where Montana has been, so that each can contribute to its future.

—Todd Bottorff, Publisher

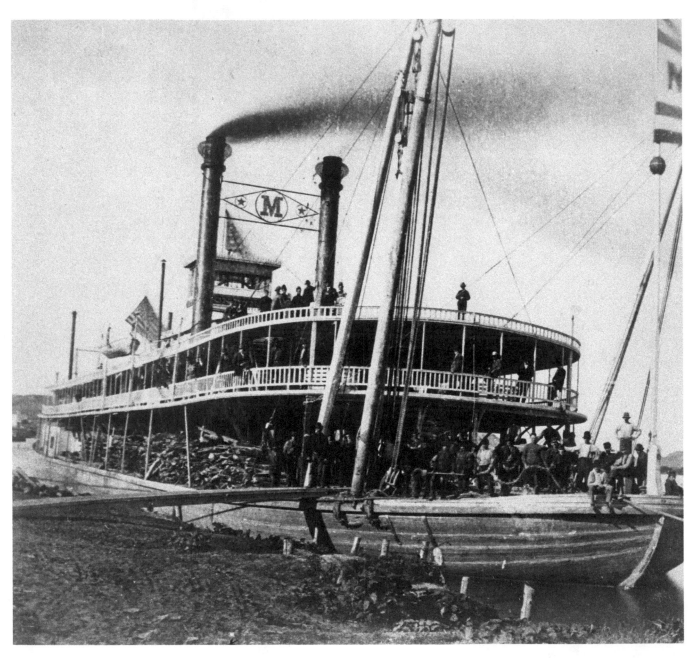

Fort Benton served as a major steamboat port for travelers to Montana for nearly 30 years. This photo shows the three-story paddle wheeler *Montana* in 1879. The largest ship to reach Fort Benton, it ran aground in 1884 on the banks of the lower Missouri.

STATE ORIGINS IN A CENTURY OF CHANGE

(1860–1899)

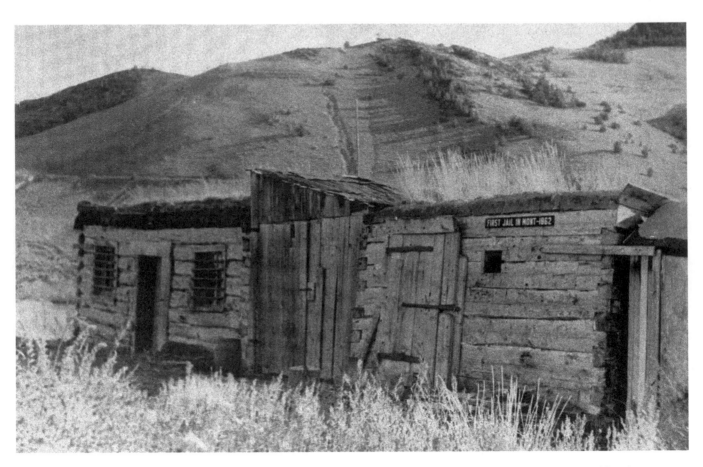

Sheriff Henry Plummer built the first jail in Montana by soliciting donations from the residents of Bannack, a gold rush camp with 3,000 residents, in 1863 (not 1862, as indicated on the sign in this photo). Suspecting that Plummer was actually the leader of a vicious gang of road agents, vigilantes hanged him in 1864.

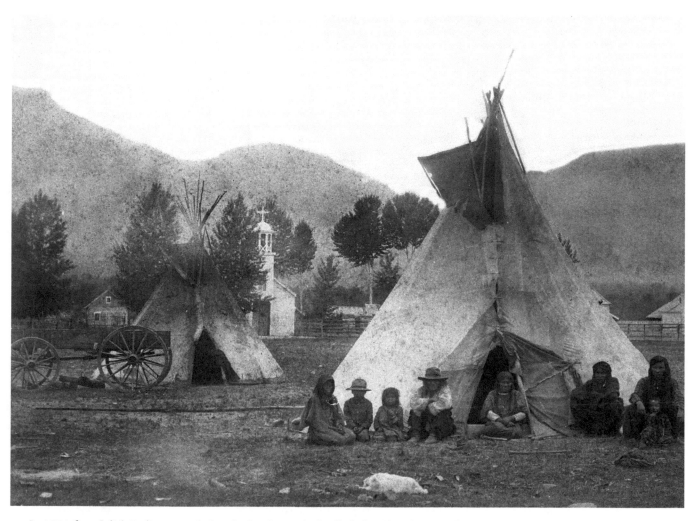

In 1831 four Salish Indians traveled to St. Louis to ask the Catholic Church to send priests to Montana. In 1841 several "Black Robes" arrived in the Bitterroot Valley and built St. Mary's Mission. The mission church can be seen behind the tepees in this 1880s photo.

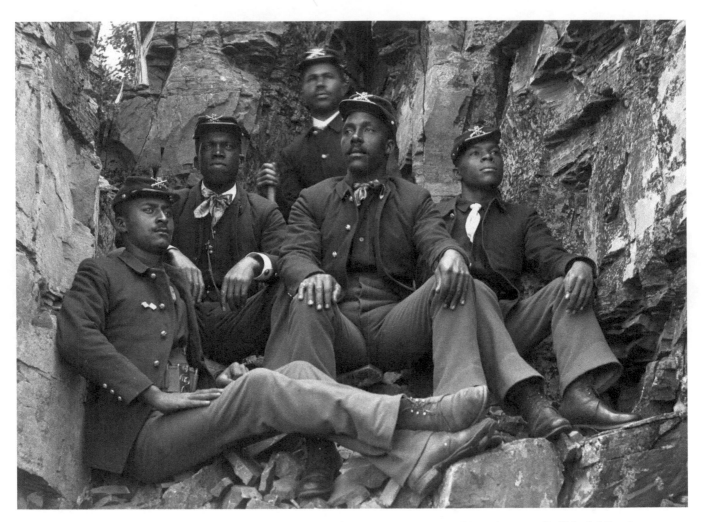

The 25th Infantry Regiment, an African American unit, arrived in Montana in 1888. Given the name Buffalo Soldiers by the American Indians, the troops were stationed at Fort Custer, For Shaw, and at Fort Missoula, where these soldiers were photographed. The regiment left Montana in 1898 upon the outbreak of the Spanish-American War.

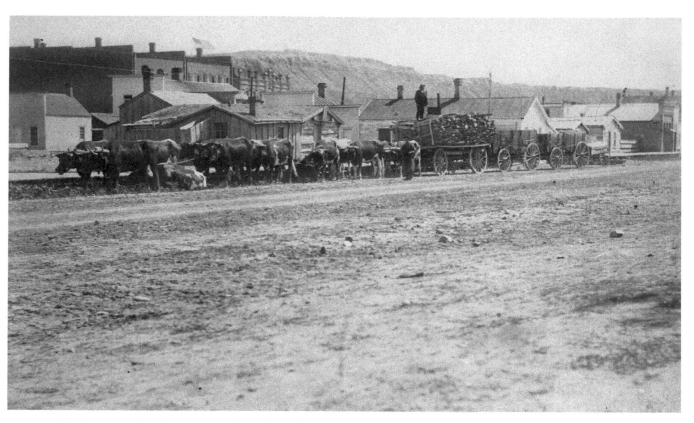

The American Fur Company established a trading post on the upper Missouri in 1847, and Fort Benton soon became an important steamboat port. The freight was off-loaded from the steamboats to wagons like this Fort Benton bull outfit driven by John Giesey.

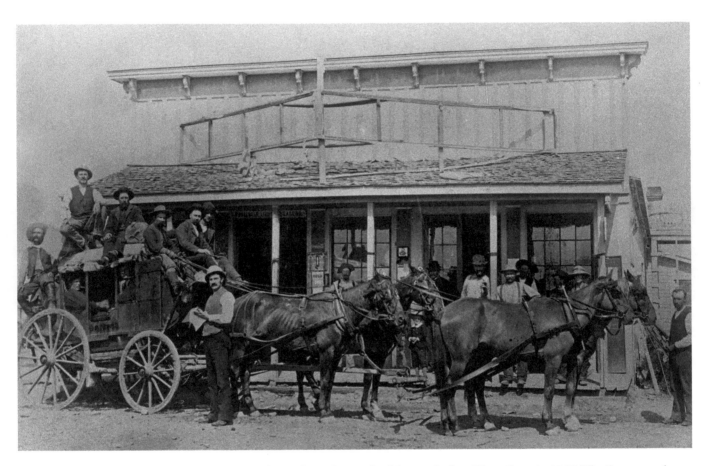

Passengers aboard a Concord Coach prepare to depart from George Steele's store in Sun River Cross in 1885. The Benton and Helena Stage operated for a number of years until the coming of the railroad finally doomed the era's steamboats and stagecoaches.

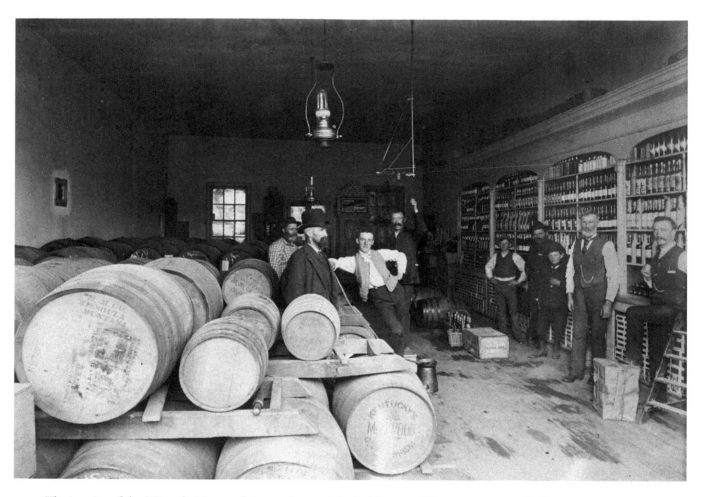

The interior of the Missoula Mercantile is seen here as it looked in 1890. The Nez Perce War broke out during the building's construction in 1877, and Missoula citizens sought shelter behind its brick walls. The extensively remodeled building is now home to a Macy's department store.

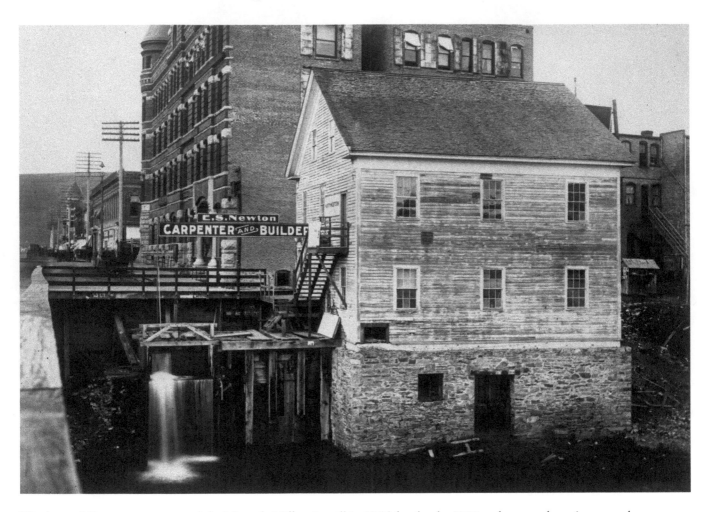

Worden and Company constructed the Missoula Mills gristmill in 1866, but by the 1890s, when seen here, it was used as a carpentry shop by local contractor C. S. Newton, who liked to decorate his building with American flags on patriotic holidays. The mill was torn down in 1912.

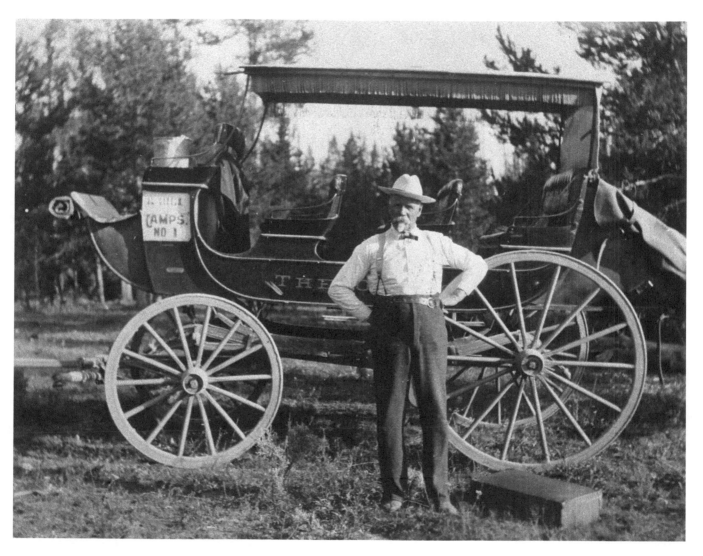

Bozeman resident George W. Wakefield began operating the first stage line into Yellowstone National Park in the 1880s. The former gold prospector charged $40 for a ten-day, all-expenses-paid camping tour of the park aboard one of his ten-passenger Concord Coaches.

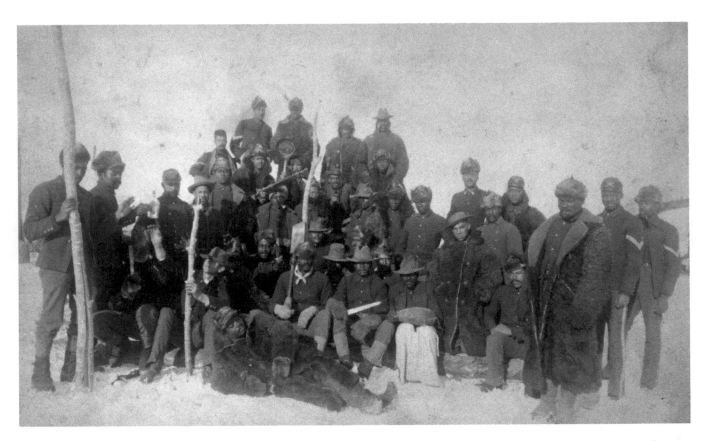

Four companies of the 25th Infantry spend several cold months stationed at Fort Keogh during the Sioux uprising of 1890 but never saw action. Named for one of Custer's officers, Fort Keogh is today a United States Department of Agriculture livestock and range research lab.

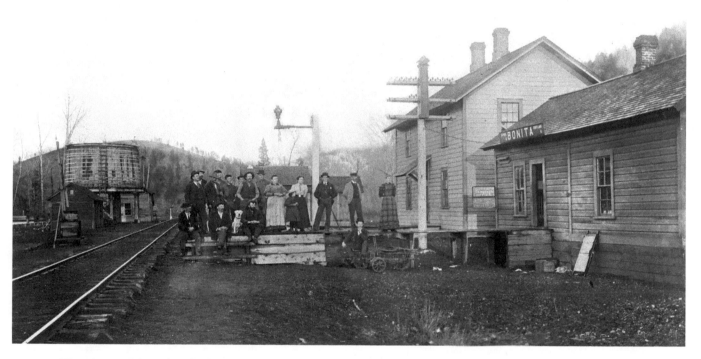

This photo of the railroad siding at Bonita, located near Beavertail Hill, was taken in the years prior to the tracks washing away during the 1908 flood of the Clark Fork River. The Bonita post office closed in 1942, and little trace of the town can be seen today.

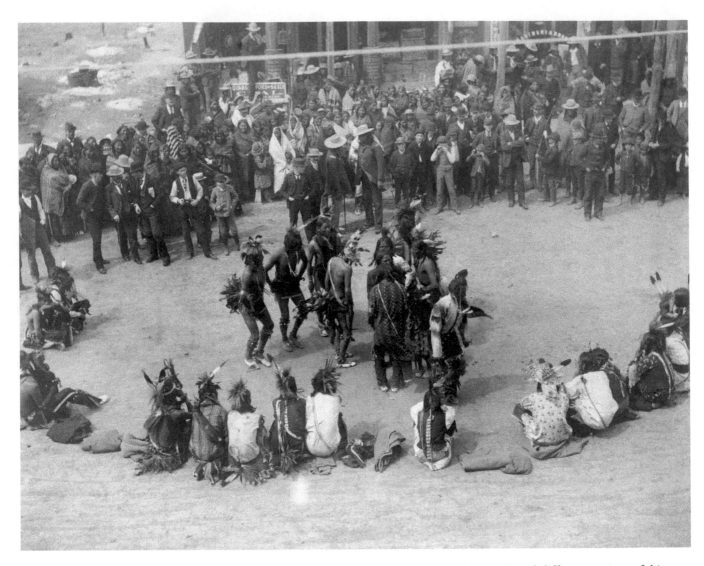

Northern Cheyenne perform the grass dance, also known as the Omaha dance, around 1891. Several different versions of this ceremonial dance still exist and are performed by a number of tribes. Each summer, Cheyenne and other native tribes follow the traditional powwow circuit.

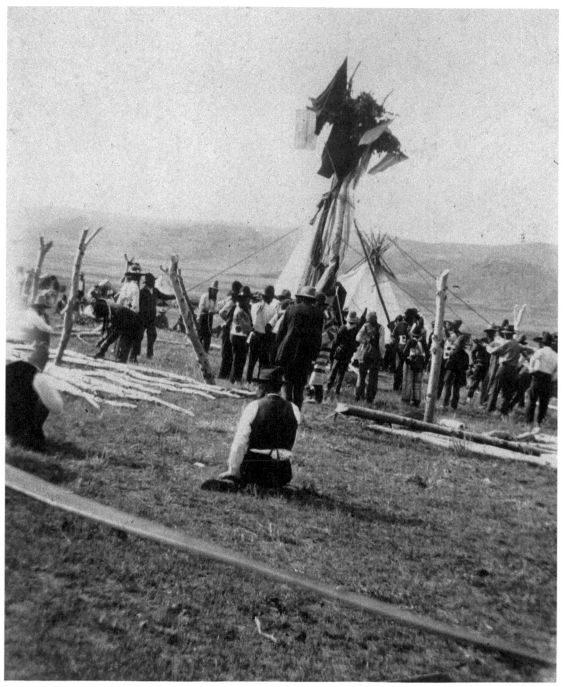

The sun dance was the most important communal and religious celebration of the Plains Indians. Each tribe had its own customs, and the celebration could often last as long as a week. A sun dance pole is visible here at center, with a large tepee behind.

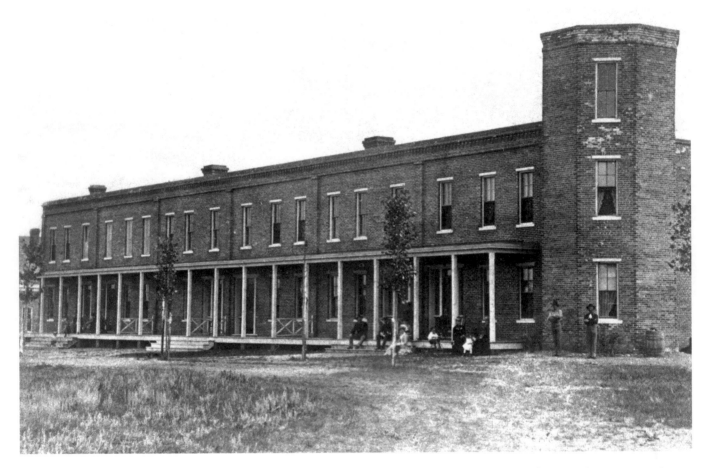

Fort Assiniboine was built in 1879 near present-day Havre. Housing more than 500 men, it was the largest military post in the state. See here around 1890, it was abandoned in 1911 and is now an agricultural research station. Some original fort buildings remain, including this officers' quarters.

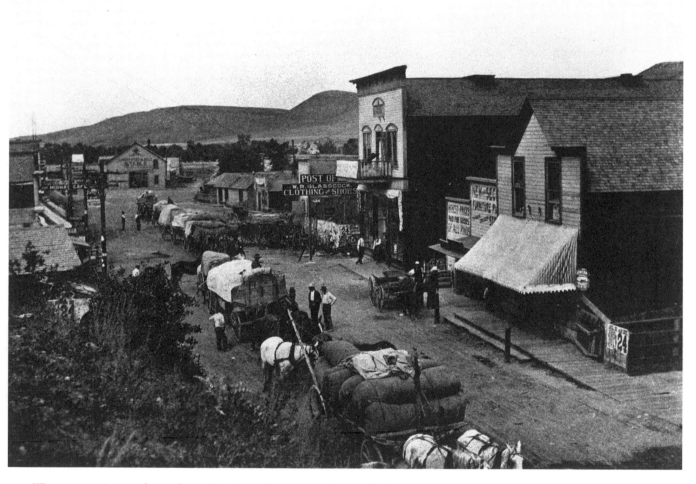

Wagons carrying wool pass through Belt on their way to Great Falls. Belt was a thriving mining town that supplied coal to the Anaconda Mining Company and to the steamboats at Fort Benton. By the 1880s, hundreds of thousands of sheep were being driven into central Montana.

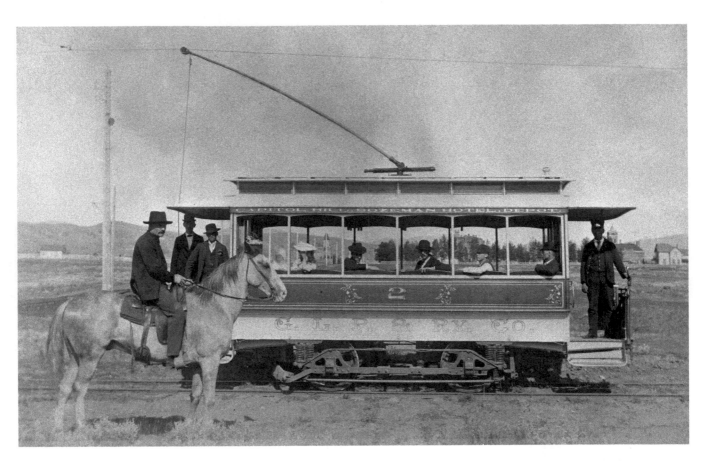

An electric streetcar belonging to the Gallatin Light, Power and Railway Company sits on its track in Bozeman. The line was installed in 1892, not long before this photo was taken, and ran until 1921. Most of Montana's larger cities operated electric streetcars during the 1890s.

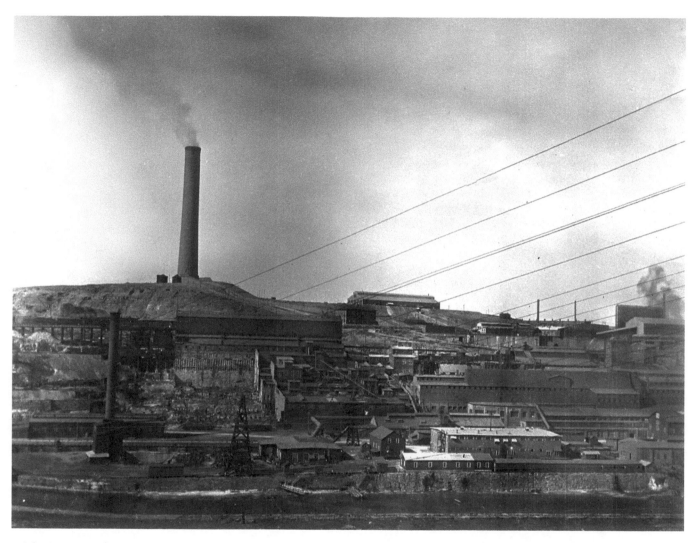

The Boston and Montana Company copper smelter at Black Eagle opened in 1893. Bought by the Anaconda Mining Company in 1910, the plant employed 2,000 men but proved to be an environmental disaster. An audience of 40,000 watched when the big stack was dynamited in 1982.

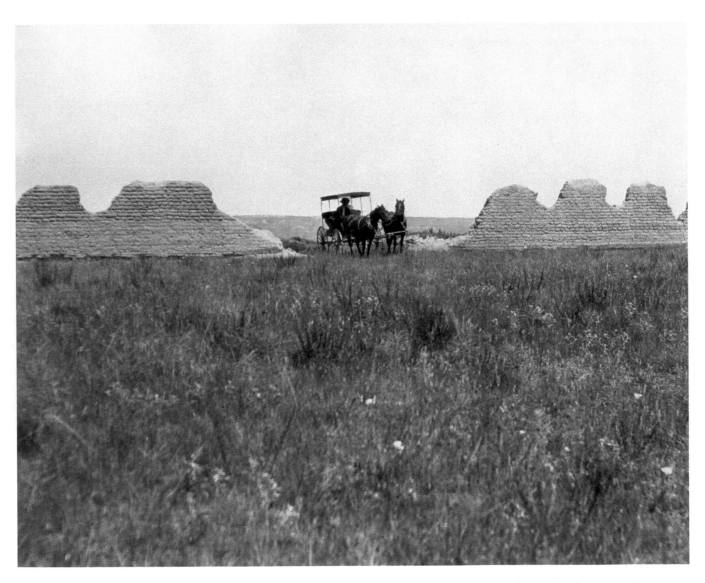

A wagon picks its way through the remains of Fort C. F. Smith. Located on the Big Horn River, the fort was built in 1866 to protect travelers along the Bozeman Trail from hostile Indians who claimed the area. Cut off for months at a time, the garrison abandoned the post in 1868.

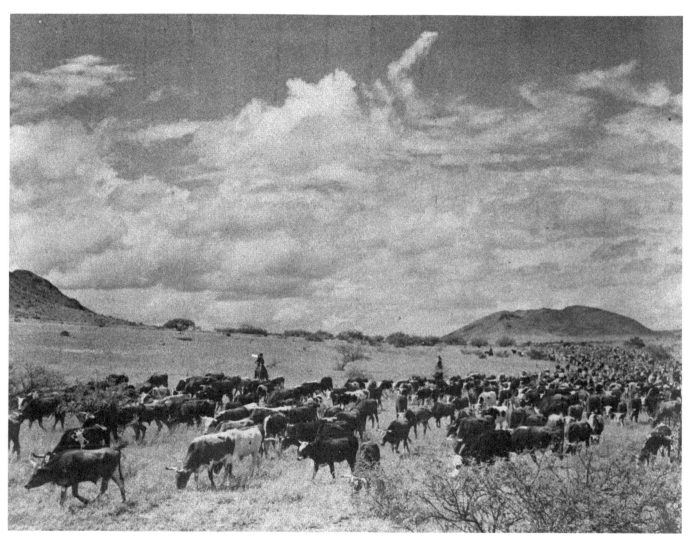

Cowboys drive a herd of shorthorn cattle under the big sky in this iconic photo. Pioneer cattleman Conrad Kohrs introduced shorthorns to Montana in 1871. The death of hundreds of thousands of cattle during the hard winter of 1886 brought an end to the open range.

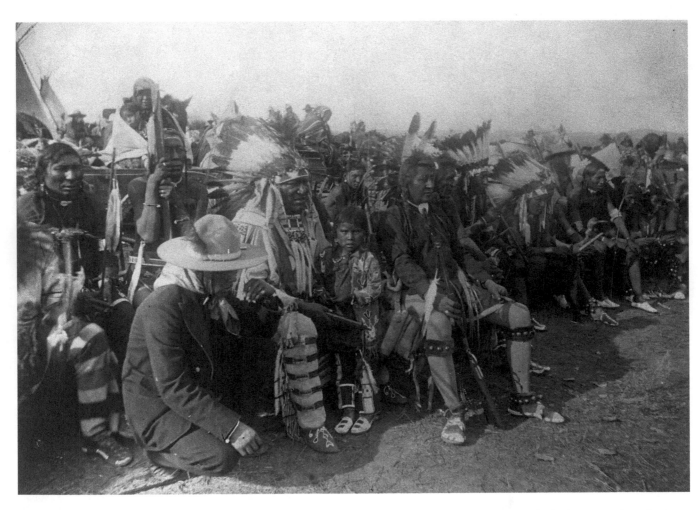

Two Leggings, Chief Plenty Coups, and other Crow elders pose in powwow dress. The Crow prefer the be known as Apsáalooke, which means "big-beaked bird." The Crow Fair remains one of the oldest and largest powwows in the country.

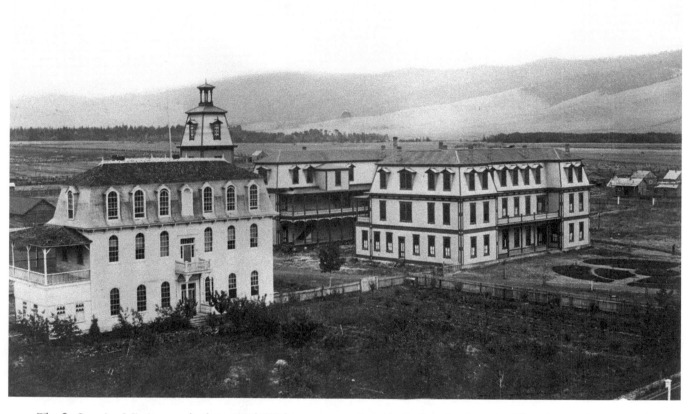

The St. Ignatius Mission was built in 1854. Within a year nearly 1,000 Indians lived nearby. This photo, taken around 1890, shows the boys' barracks at the boarding school. A new mission church built in the early 1890s included murals painted by Brother Carignano and remains a popular tourist destination today.

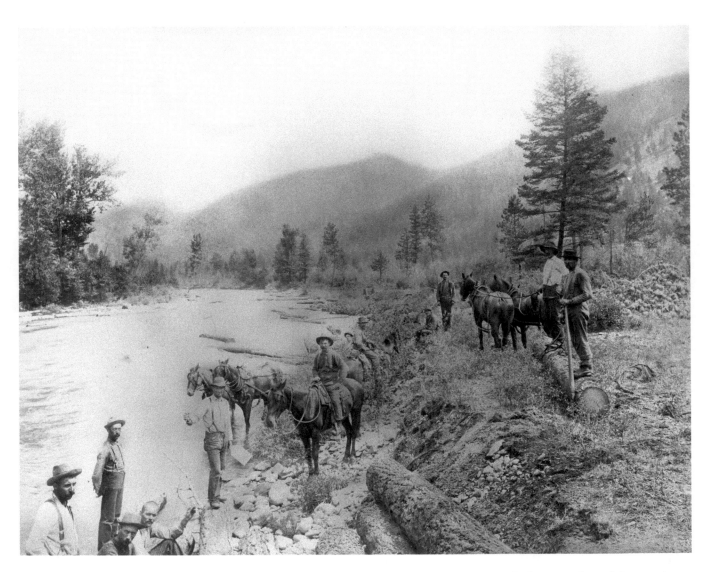

A lumber crew floats logs down lower Rock Creek near Quigley, in Granite Country, in 1896. The logs were bound for a road construction project. The area is now a world-famous destination for fly fishermen.

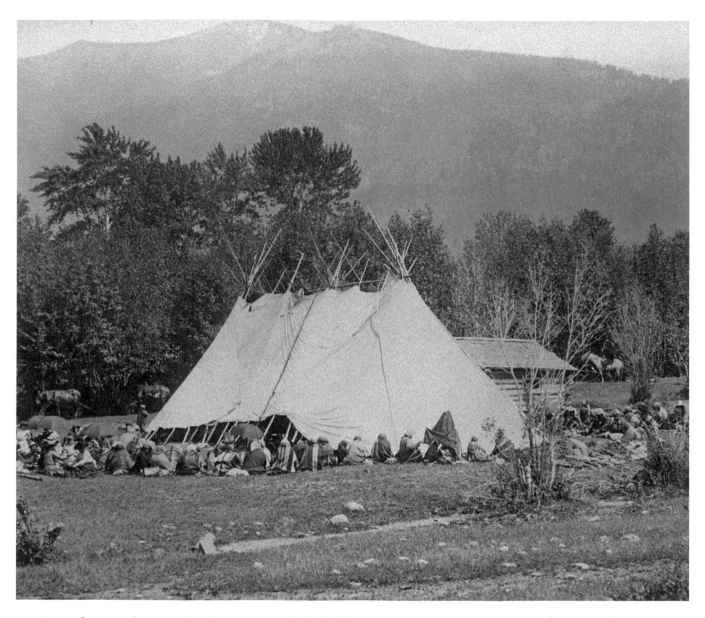

An overflow crowd sits outside a large tepee on the Flathead Reservation as tribal members mourn the recently deceased son of a chief. Home to the Confederated Salish, Kootenai, and Pend d'Oreille, the reservation was established by the Hellgate Treaty of 1855.

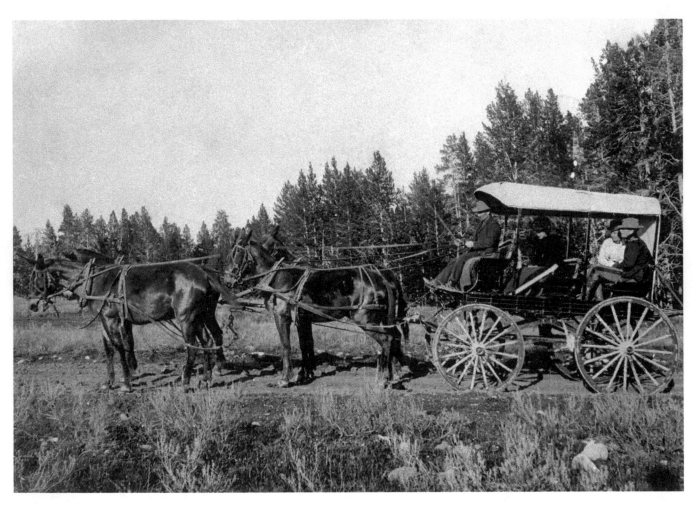

Almost 5,000 people, including this fishing party aboard a mountain wagon, visited Yellowstone National Park in 1897, by which time America's first national park was a quarter-century old. While the railroad reached Gardiner in 1902, the first automobile did not venture into the park until 1915.

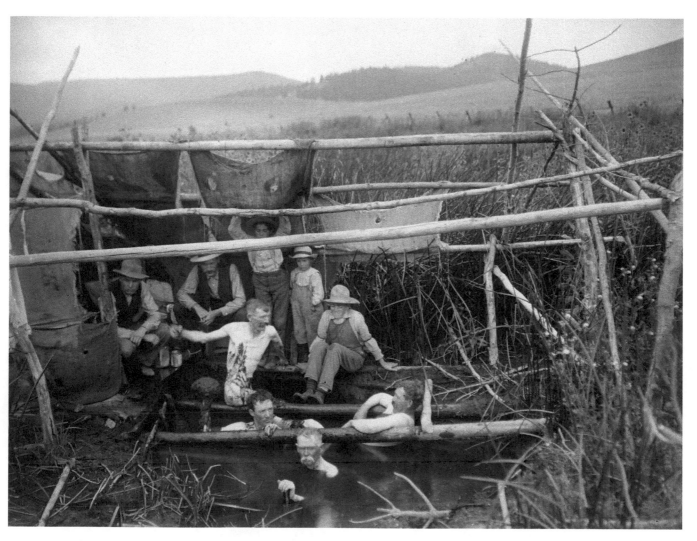

A group of men enjoy a mud bath near Hot Springs. Settlers and Indians alike shared a belief in the rejuvenating powers of the springs.

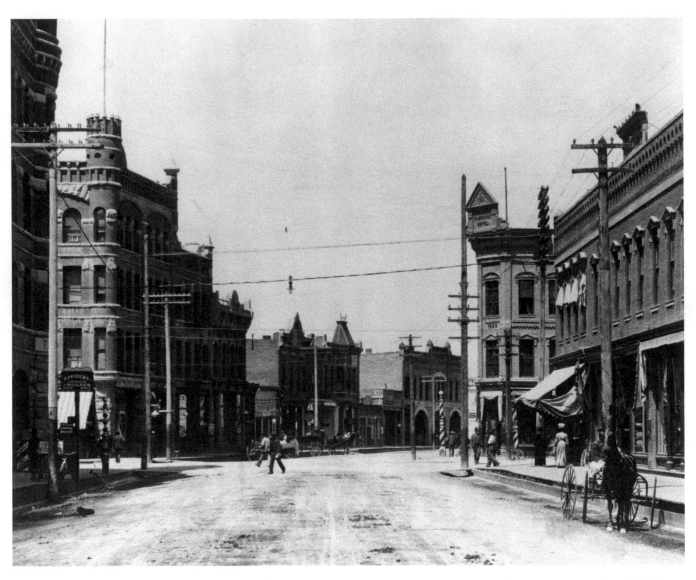

This view of Front Street in Missoula was taken around 1900. Front Street followed the course of the Mullan Road, established Fort Benton and Walla Walla, Washington, in 1860, and was the heart of Missoula's red-light district at the time.

Montana's Copper Collar

(1900–1919)

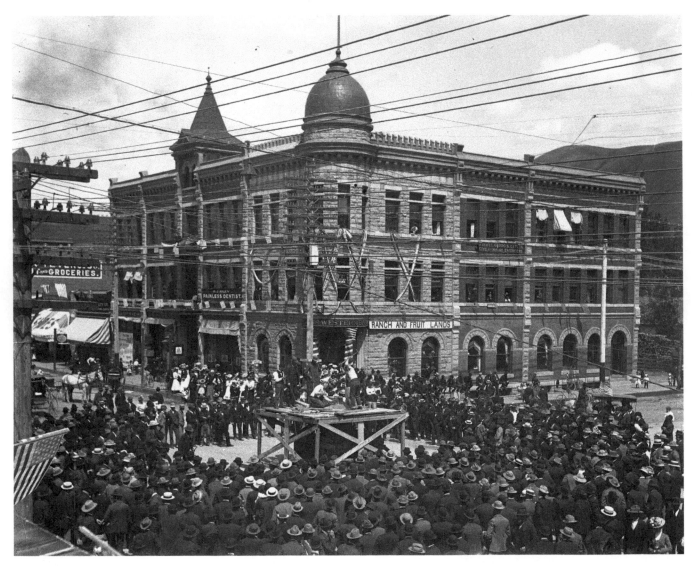

A crowd gathers at the corner of Higgins and Main in Missoula to watch miners compete in a drilling contest. Note that electrical lines proliferated by 1900.

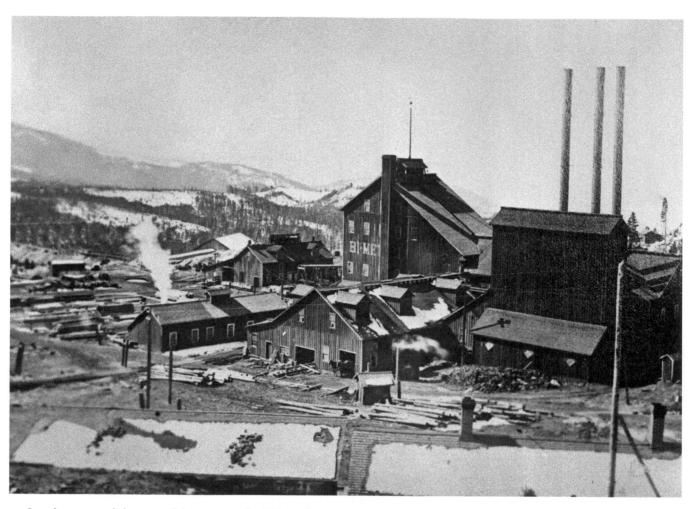

Seen here around the turn of the century, the Bi-Metallic Mine at Granite stat atop one of the richest silver deposits ever found. Between 1885 and 1892 almost $20 million in ore came from the mines of Granite. A fire in 1958 destroyed many of the above-ground buildings.

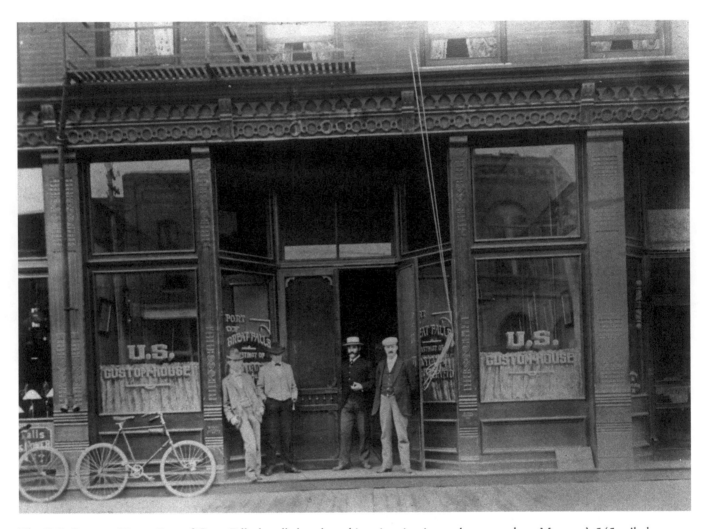

The U.S. Customs House, Port of Great Falls, handled trade and immigration issues that arose along Montana's 545-mile-long border with Canada. This view captures the building's ornate design details and a window reflection of the buildings across the street.

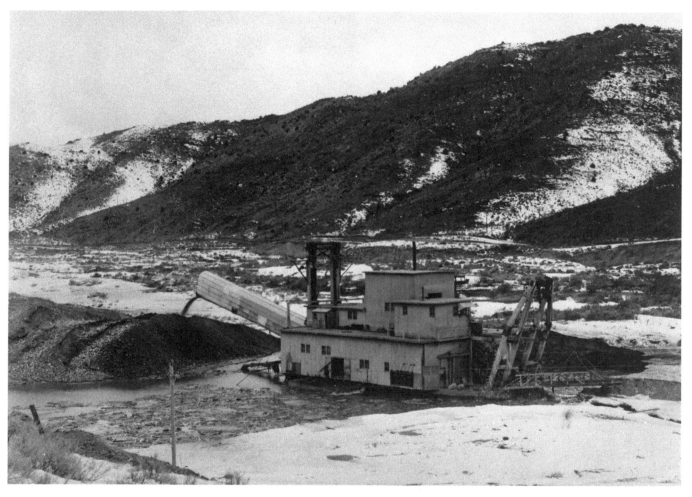

From 1898 to 1922, at least five floating dredges worked the gold-bearing gravel of Alder Gulch. This photo of the Cowrey Dredge No. 1 was taken several miles below Nevada City. Most of the city's buildings were eventually destroyed by dredges.

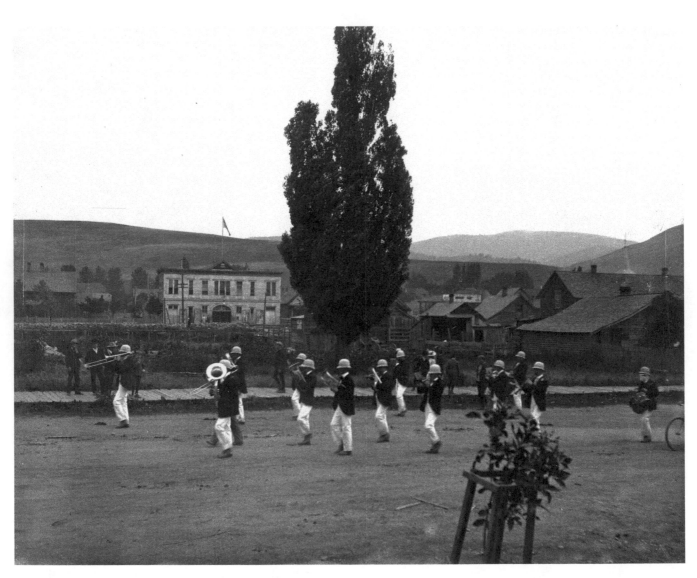

A marching band parades down East Front Street in Missoula around 1900. Marching bands originated from military bands and became popular in the late 1880s. Amateur photographer John Dunn snapped this photo.

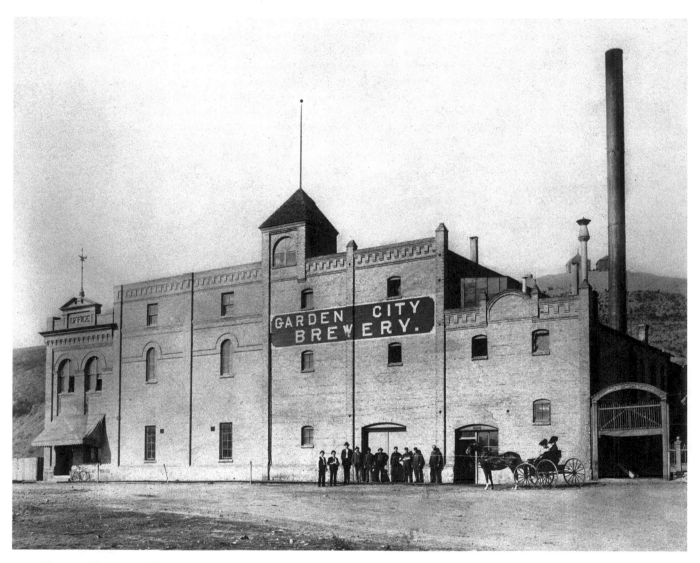

Photographed around 1902, this brewery was built near Missoula's Rattlesnake Creek in 1874 and by 1895 was known as the Garden City Brewery. By 1910 its signature brew was Highlander Beer. The brewery closed in 1964 and was torn down during construction of Interstate 90.

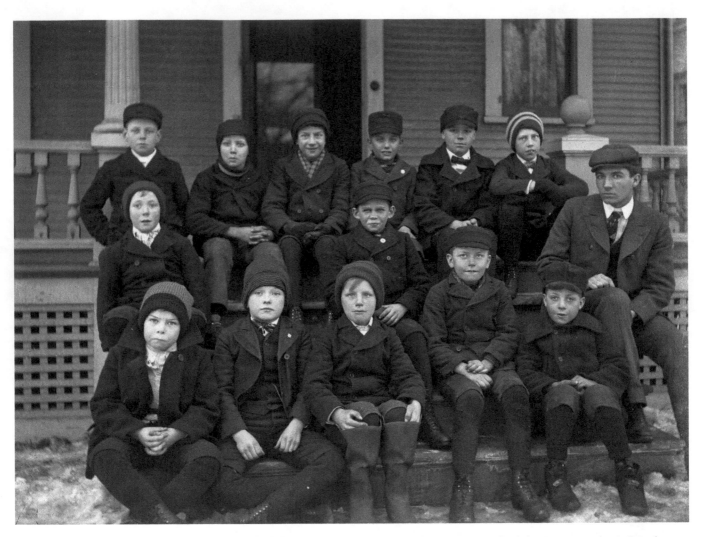

Located near the Two Medicine River on the Blackfeet Reservation, Holy Family Mission was built by Jesuits in 1886. Seen here in 1902, the vocational school served 100 boys and girls, primarily Blackfeet, who were forced to abandon their native customs and language.

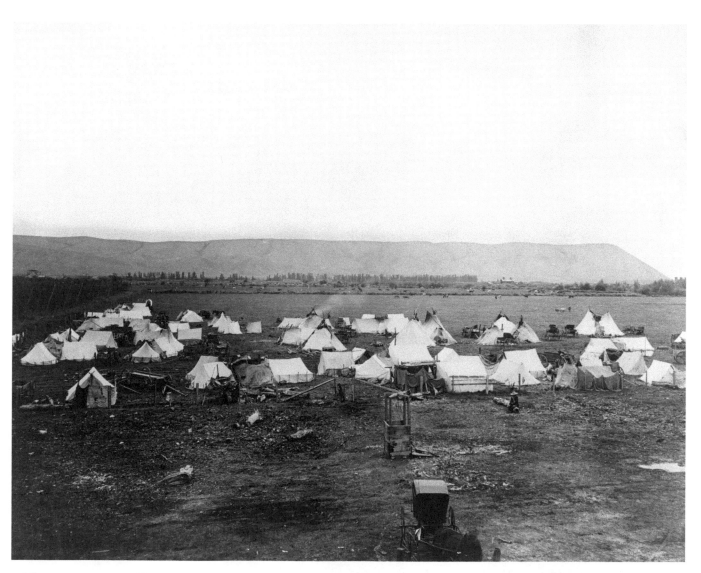

The near extinction of bison forced American Indians to replace their traditional hide tepees with canvas-wall tents. A water well and horse-drawn buggy can be seen in the foreground of this early-1900s view of a Crow village.

This 1904 image shows a boy posing in front of the belching smokestacks of the "Richest Hill on Earth." Mining operations contaminated Butte's air and water with arsenic and heavy metals for more than a century. In 1985 the Environmental Protection Agency declared Butte the center of the nation's largest Superfund site.

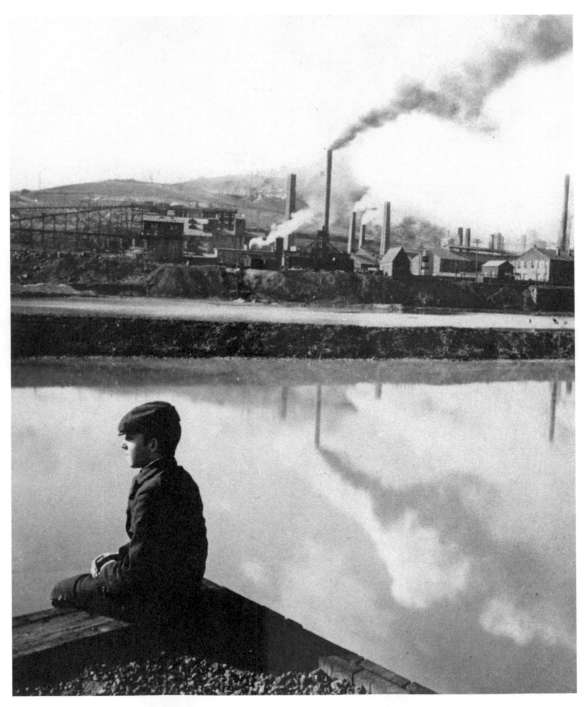

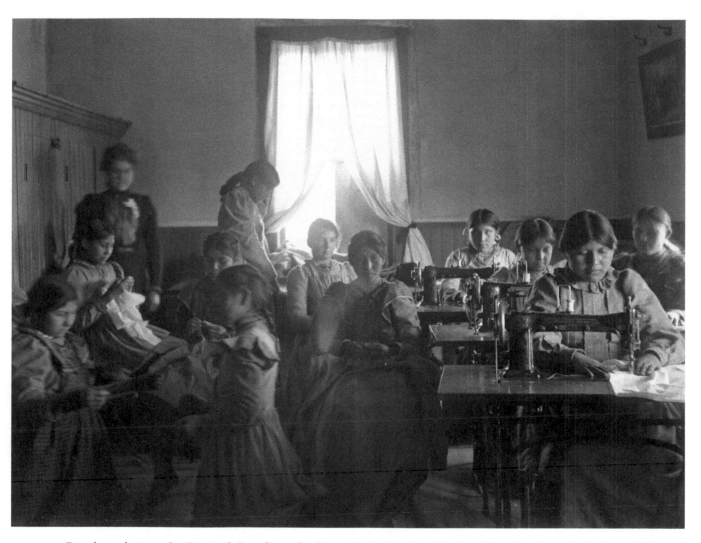

Female students at the Cut Bank Boarding school practice their sewing. The boarding schools taught both academic and vocational skills in an attempt to assimilate American Indians into Western culture. Native languages and traditional activities were discouraged.

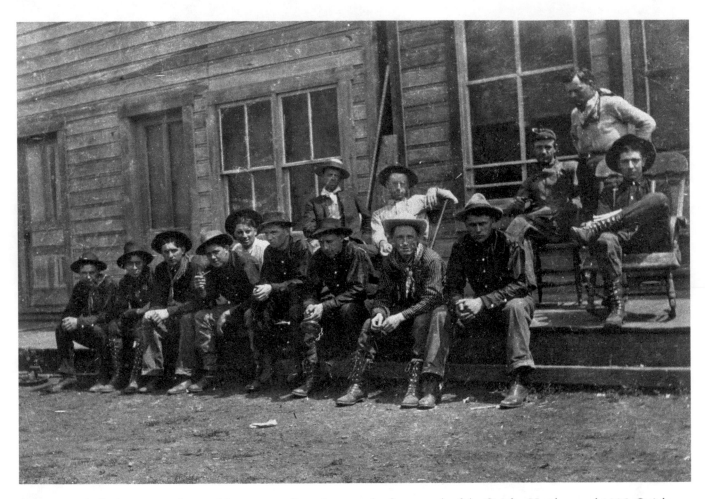

A dour crowd of miners, wranglers, and loggers pose for a photo on the front porch of the Quigley Hotel around 1905. Quigley was located on Rock Creek, a few miles from the junction with the Clark Fork River. The area today is a popular destination for fly fishermen.

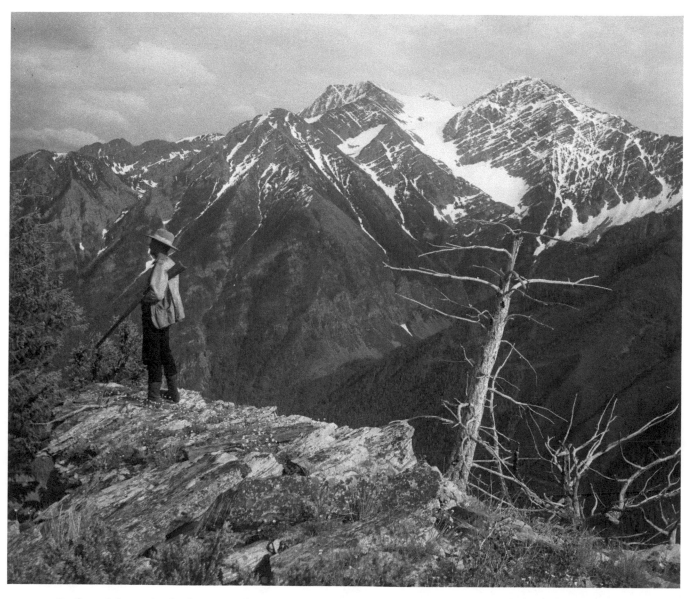

Professor Morton J. Elrod gazes on the Mission Mountains around 1905. A botanist, Elrod established the Flathead Lake Biological Station in 1899 and served as the first naturalist in Glacier National Park. He also wrote one of the first guidebooks on the park.

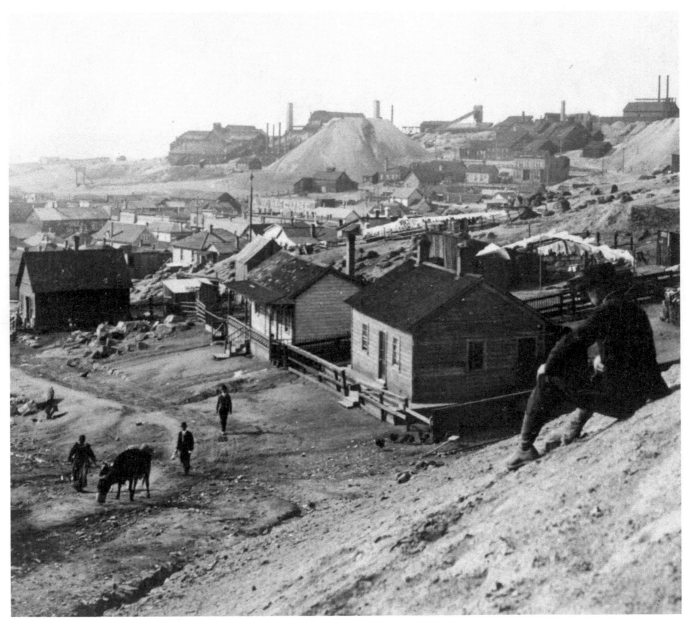

Located just north of Butte, Walkerville was named for the Walker brothers of Salt Lake City, owners of the famous Alice Mine in Butte. Seen here around 1905, Walkerville was primarily settled by Cornish miners who lived close to the mines, smelters, and tailing piles of the Richest Hill on Earth.

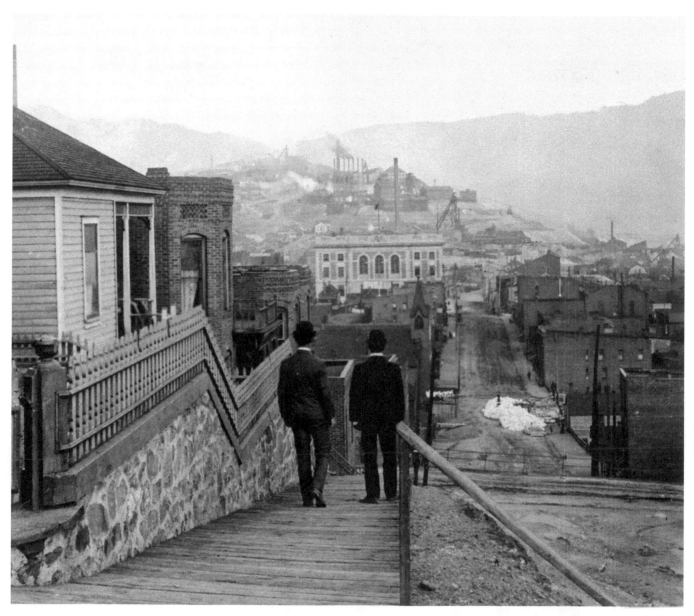

The Butte post office can be seen in this early twentieth century view of East Copper Street, better known as Dublin Gulch due to the many Irish miners who lived there. By 1916 Butte had a population of nearly 100,000. The city streets were built atop almost 2,000 miles of underground tunnels.

A crowd gathers at the corner of Broadway and Montana streets to watch smoke billowing from a fire in downtown Butte. This fire started in the basement of the Symons Dry Goods Company on September 24, 1905. The City Library and several commercial blocks were destroyed before a torrential rainstorm quenched the flames.

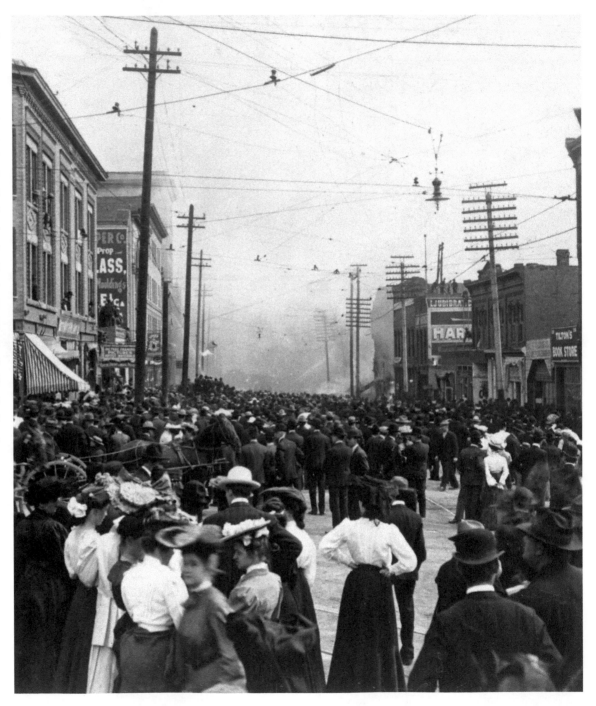

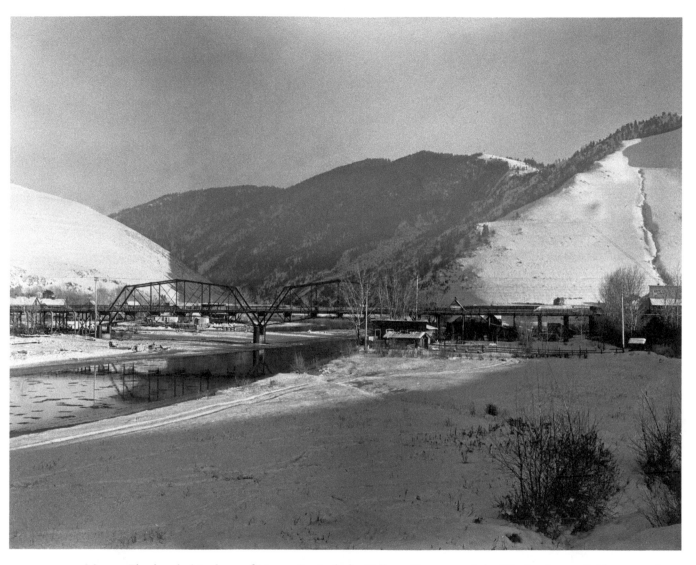

Morton Elrod took this photo of Mount Sentinel, the Hellgate Canyon, and the Higgins Avenue Bridge on a wintry Missoula day. This bridge collapsed during the 1908 flood of the Clark Fork River, then known as the Missoula River, cutting the city in half.

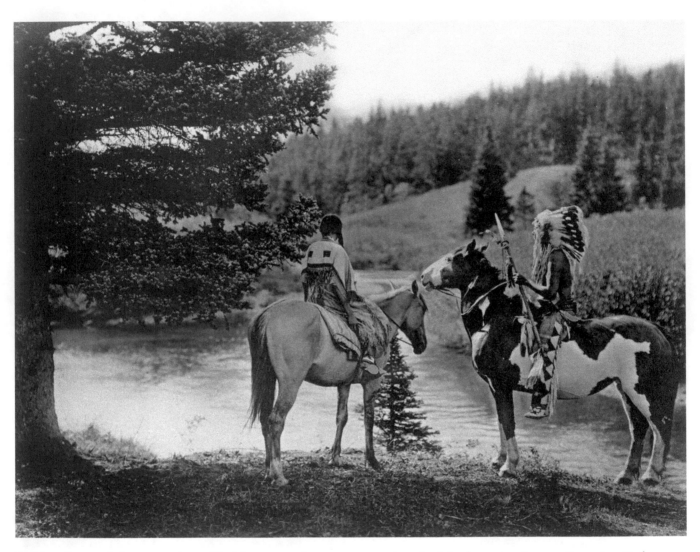

In this early twentieth century view, a Blackfeet man and woman pose on horseback in the mountains near Browning. Both are dressed in traditional garb, with the man wearing an eagle-feather warbonnet that signifies his acts of bravery. Several photographers helped document American Indian culture during this era.

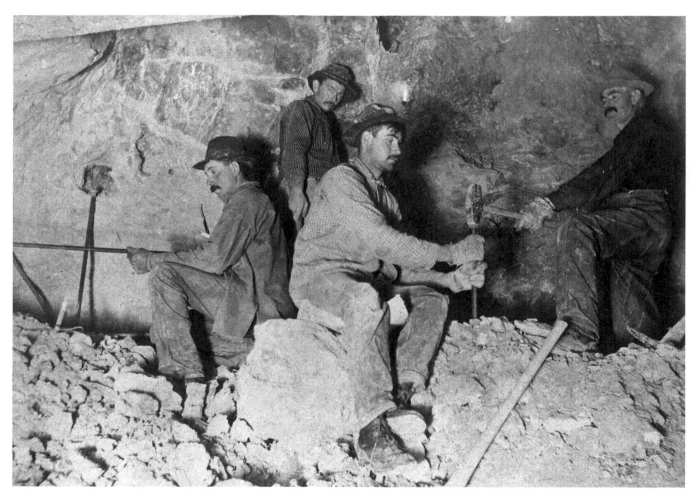

Prospector Jake Hoover was panning for gold in Yogo Gulch in the 1890s when he discovered small blue gemstones in his pan. They were later identified as sapphires of an unusually high quality, leading to the region's longtime renown as the source of a gem eventually designated the Montana state gemstone. Here miners search for sapphires in the underground workings of a Yogo mine.

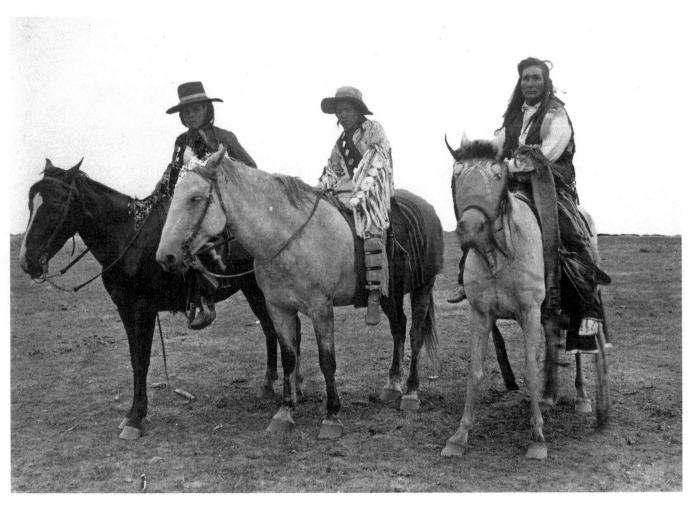

Joseph White Bull, at right, is seen with two acquaintances in this early twentieth century photograph. White Bull, a Sioux warrior and nephew of Sitting Bull, was a veteran of 19 battles by the age of 27. He is often credited with killing George A. Custer at the Battle of the Little Big Horn. White Bull lived to the age of 98.

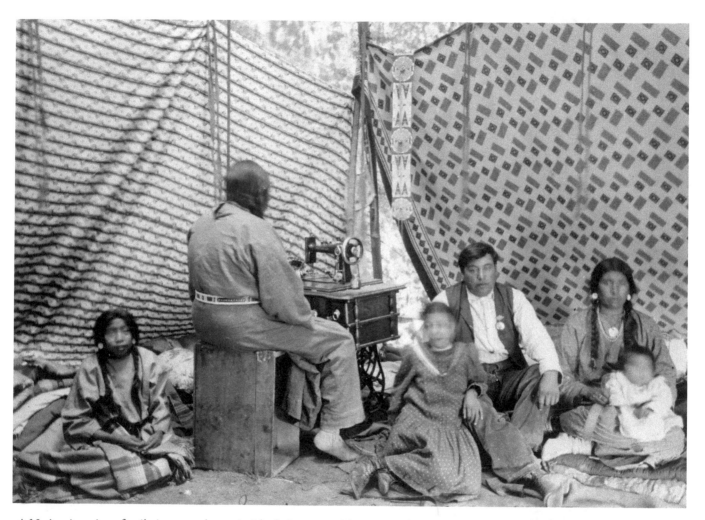

A Native American family is seen at home inside their tepee, with one member using a sewing machine, around 1906. This photo demonstrates the transition that occurred as traditional moccasins and buckskin clothing were replaced by leather shoes and garments made of fabric.

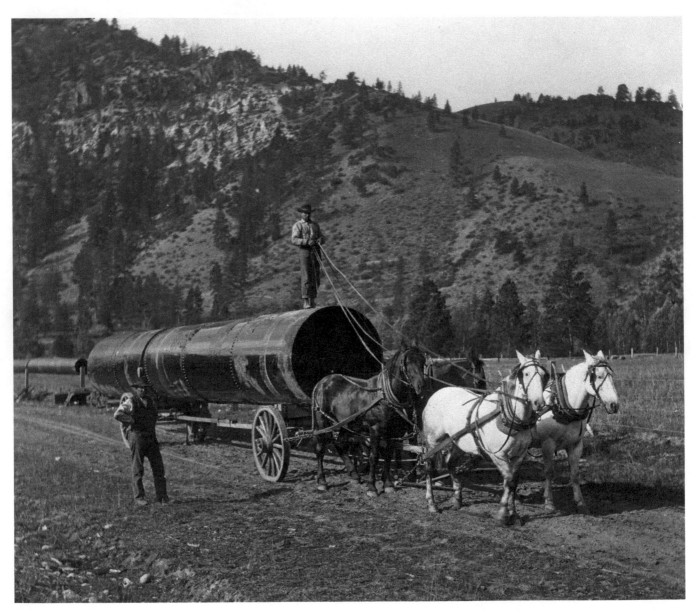

Millionaire Marcus Daly planned a major expansion of the irrigation system in the Bitterroot Valley before his death in 1900, but work on the project did not start until several years after he died. This 1907 photo shows a wagon loaded with pipe for the irrigation project.

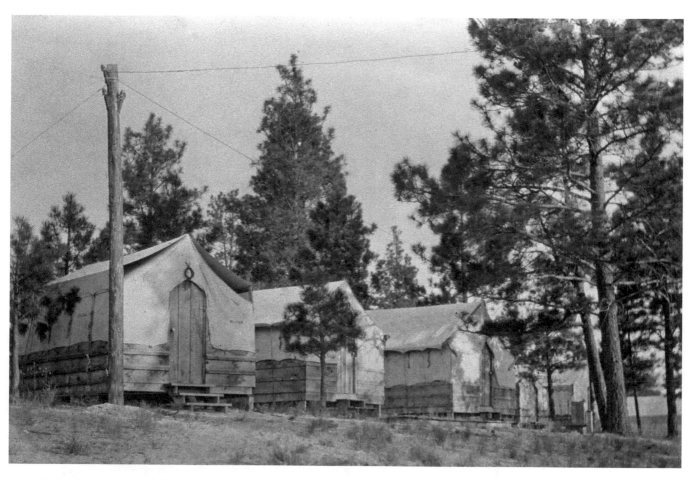

The fertile Bitterroot Valley was a perfect place for fruit orchards, a fact that farmers took advantage of after Chief Charlo and his Salish followers were finally forced to vacate the valley in 1891, 20 years after Charlo's name was reputedly forged on a treaty calling for the removal of his tribe. This photo shows a temporary camp established for fruit pickers around 1907.

Secretary of the Interior James R. Garfield and his son met with Chief Charlo and his son on the Flathead Reservation in 1907. As a congressman from Ohio (and future president of the United States), Garfield's father, James A. Garfield, had been instrumental in negotiating the Salish removal from the Bitterroot Valley some 36 years earlier, over Chief Charlo's strenuous objections.

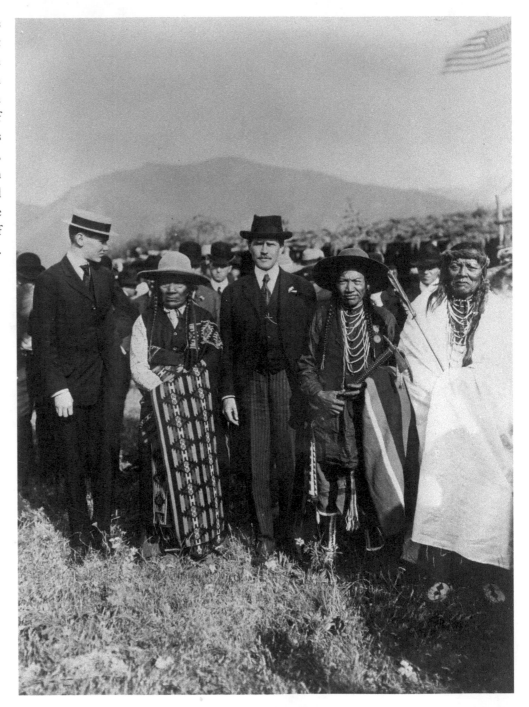

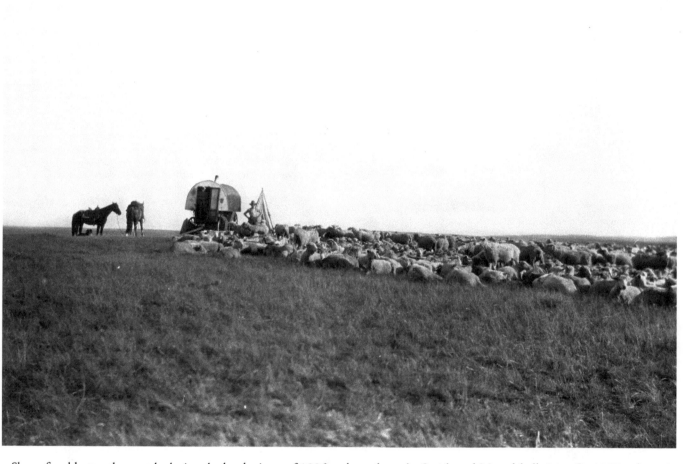

Sheep fared better than cattle during the hard winter of 1886, at least along the Smith and Musselshell rivers. By 1900 at least six million sheep ranged over Montana, making git the largest wool-growing state in the nation.

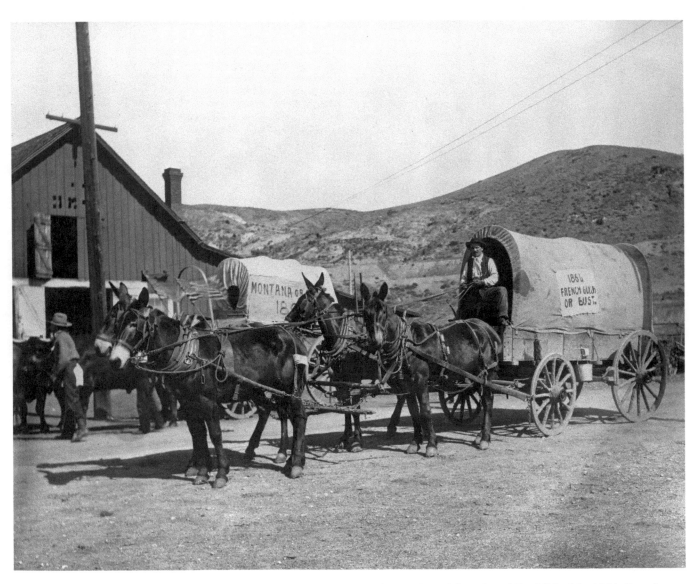

This Fourth of July photo from 1908 shows a wagon proclaiming "1864: French Gulch or Bust." Established in 1864, French Gulch was an early gold-mining camp that at one time boasted 30 houses, as well as an assortment of shops, saloons, and gambling houses. Large-scale hydraulic mining and dredging destroyed the last remnants of the camp by 1904.

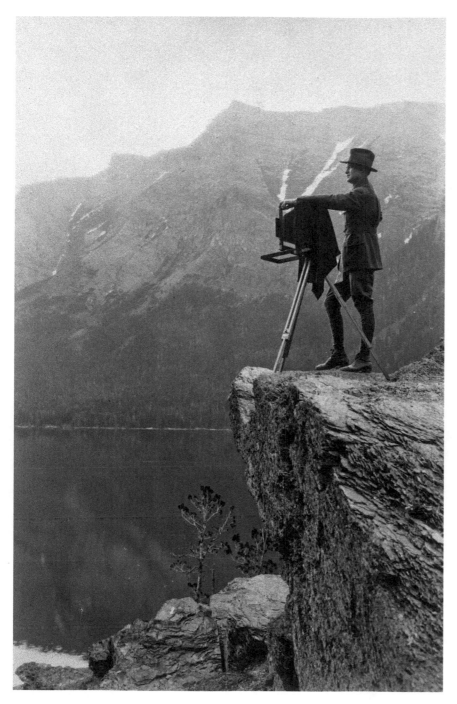

R. H. McKay, seen here with his camera, was one of western Montana's foremost photographers during the first half of the twentieth century. By 1911 he had opened his own commercial photo studio, and for the next 35 years he took thousands of images of the people and places of western Montana.

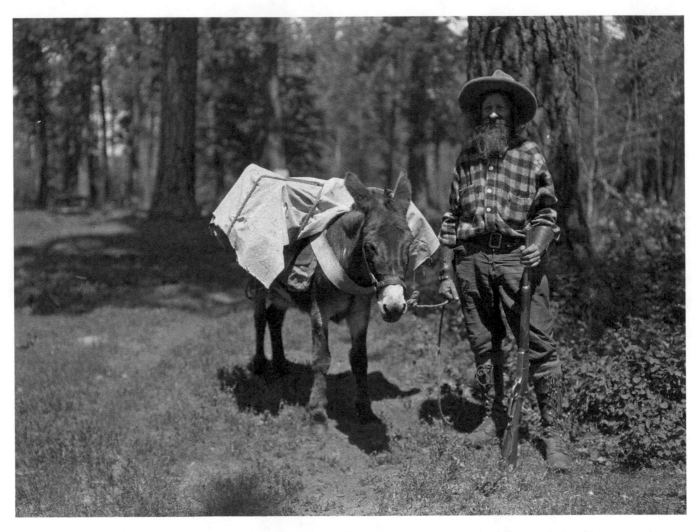

Some 50 years after the heyday of the gold rush in Montana, R. H. McKay snapped a series of photos of a local itinerant gold prospector, "Arizona Pete." In this photo, Arizona Pete and his burro pose in front of an old-growth ponderosa pine forest in western Montana.

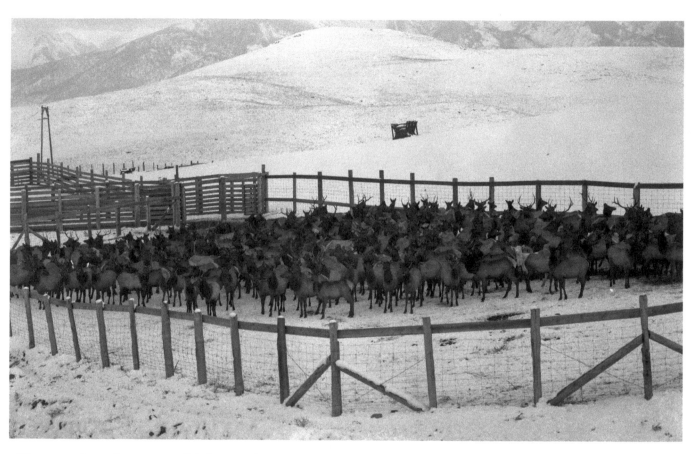

There were fewer than 50,000 elk left in North America by 1910. Over the next 30 years, more than 1,700 elk were transplanted from Yellowstone National Park and the National Bison Range to 31 location across Montana. This herd of corralled elk boasts many large bulls.

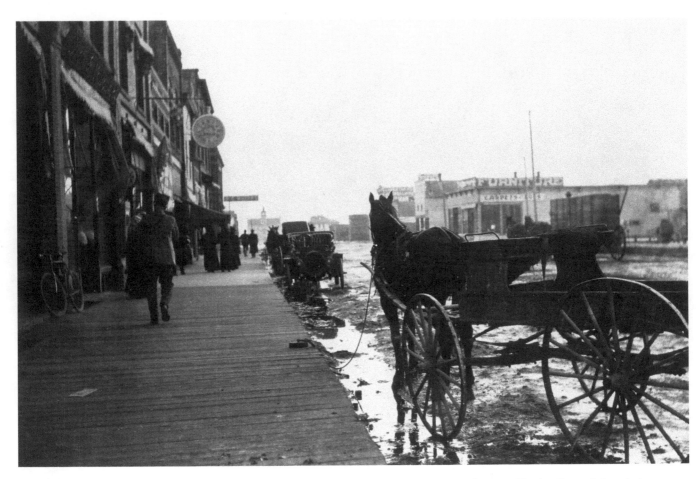

Hitched to a wagon, a horse stands patiently in the mud of Kalispell's Main Street around 1908. Charles Conrad founded Kalispell in 1891, and it soon grew into an important railroad and timber-industry center. Conrad's opulent mansion is now open to the public.

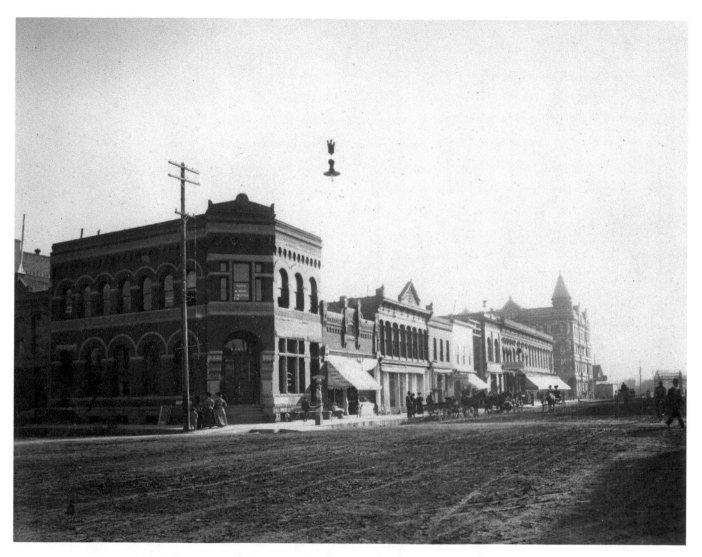

Missoula's Western Montana Bank Building is seen here at the corner of Broadway and Higgins in 1908. Missoula founder C. P. Higgins began construction of the building in 1888 but died before it was finished. His son Frank oversaw completion of the "Higgins Block" and later was elected mayor of Missoula.

Crow Indians reenact a war party for photographer Edward Curtis, who became enamored of Native American traditions after witnessing a Piegan sun dance. Curtis spent years compiling an ambitious, 20-volume photographic study of the North American Indian.

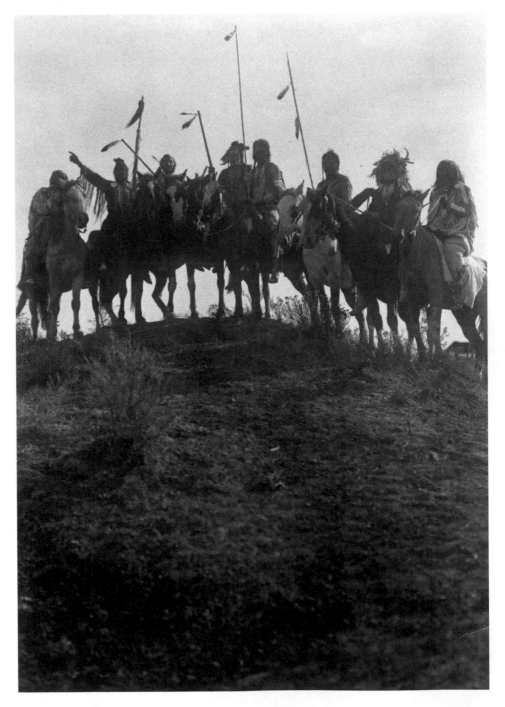

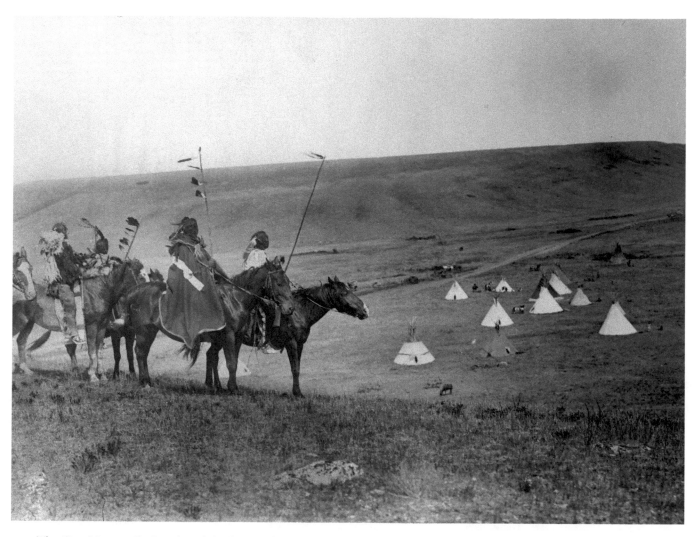

The Gros Ventre tribe has shared the Fort Belknap Reservation with the Assiniboine tribe since 1887. Named the Gros Ventre (or Big Bellies) by the French, they prefer the name A'aninin (People of the White Clay). They are related to the Arapaho and Cheyenne tribes. Edward Curtis photographed this group of A'aninin in 1908.

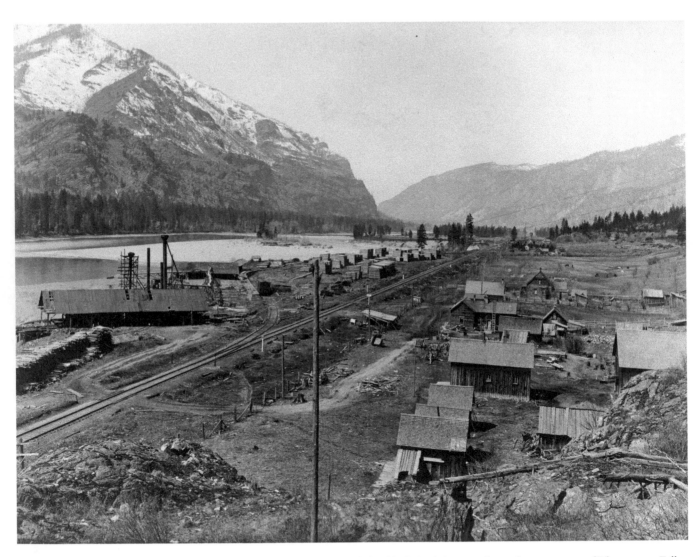

The cliff-top view shows the town of Eddy, located on the banks of the Clark Fork River a few miles upstream of Thompson Falls. Snow covers the upper slopes of nearby Eddy Mountain. Salish Post, the first Hudson's Bay Company trading post in Montana, was located nearby.

The headquarters of the Seeley Lake lumber camp, with the foreman's shack nearby, are shown here in 1909. Beginning in 1906, the Anaconda Mining Company logged 10 million board feet per year from this area. Logs were floated down the Clearwater and Blackfoot rivers to the company mill in Bonner.

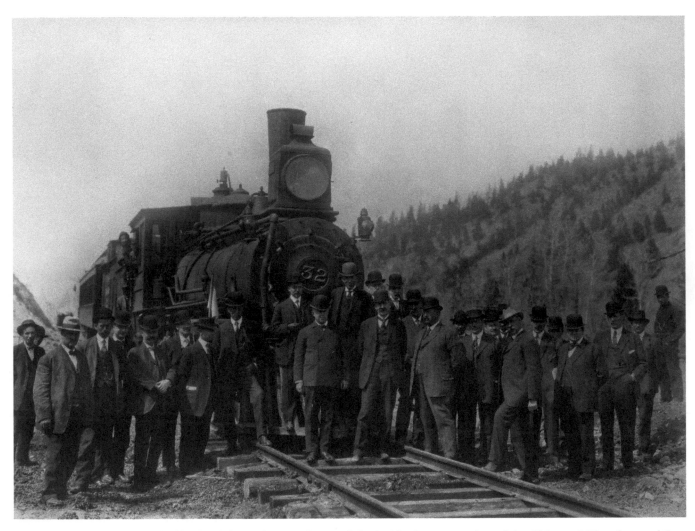

Local dignitaries and railroad officials celebrate the completion of the Pacific Coast extension of the Chicago, Milwaukee, and St. Paul Railroad at the "Last Spike" ceremony, held at Garrison on May 19, 1909. Passenger service started a year later.

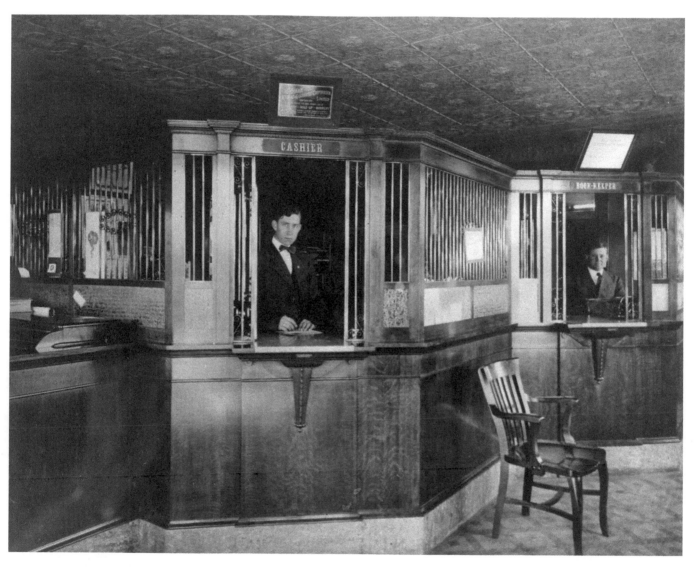

Metal cages offered the tellers of the Security State Bank and Trust Company in Polson some protection from bank robbers. A Polson institution, seen here around 1910, the bank was purchased by First Interstate Bank in 1999.

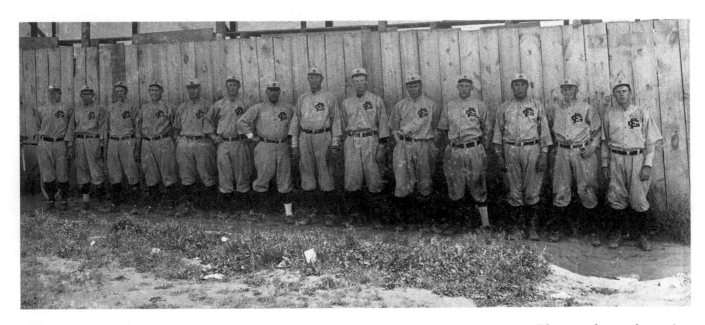

The Great Falls Electrics baseball team was formed in 1911 as part of the Union Association League. They were league champs in 1911 and 1913, but disbanded in 1917. The team returned to the field in 1948 and became an affiliate of the Brooklyn Dodgers in 1952.

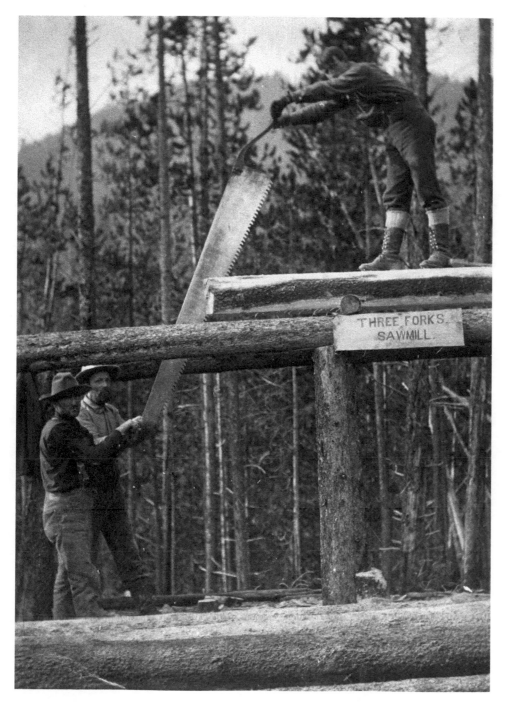

This simple pit sawmill at Three Forks in 1910 utilized a principle developed by the early Egyptians—a "top man" pulled the saw up, and the "pit man" pulled it down. The saw cut only on the downstroke.

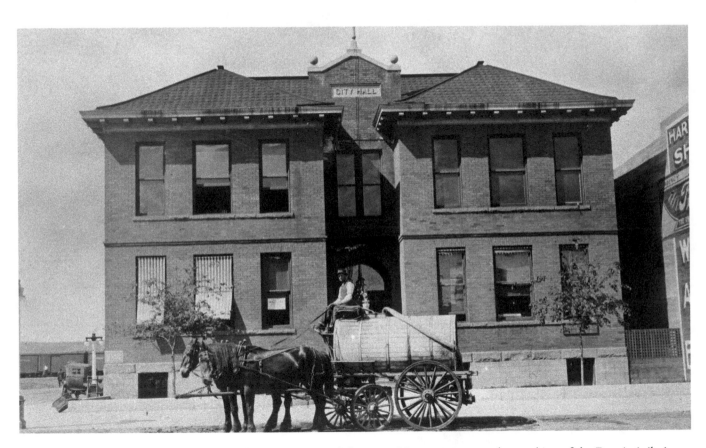

A water wagon waits in front of the City Hall in Havre around the 1912. Havre grew up on the outskirts of the Fort Assiniboine Military Reservation, and like other towns along the Hi-Line, benefited greatly when the Great Northern Railroad brought an influx of homesteaders to the area.

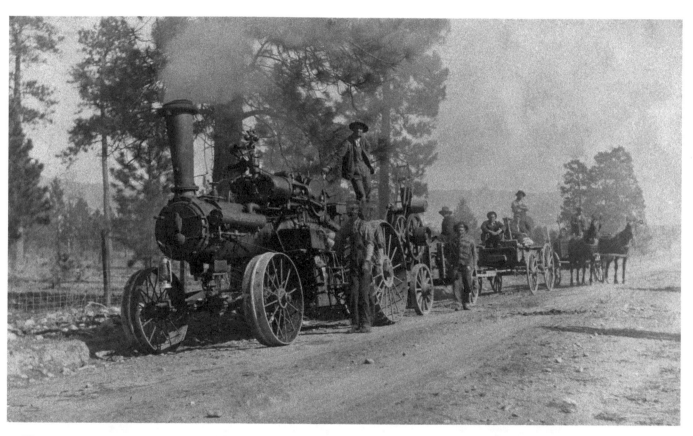

Florence men use a stream tractor and horse-drawn wagons to bale hay. After the winter of 1886, stockmen realized the value of putting up hay, and by 1900 there were 700,000 acres of hay fields in the state.

A stock wagon waits as a cowboy learns that herding bison is a little different from herding cattle. An angry bull is chasing the center horse, while the stout fence in the background is testament to the difficulty of holding bison. This photo was taken near Butte around 1909.

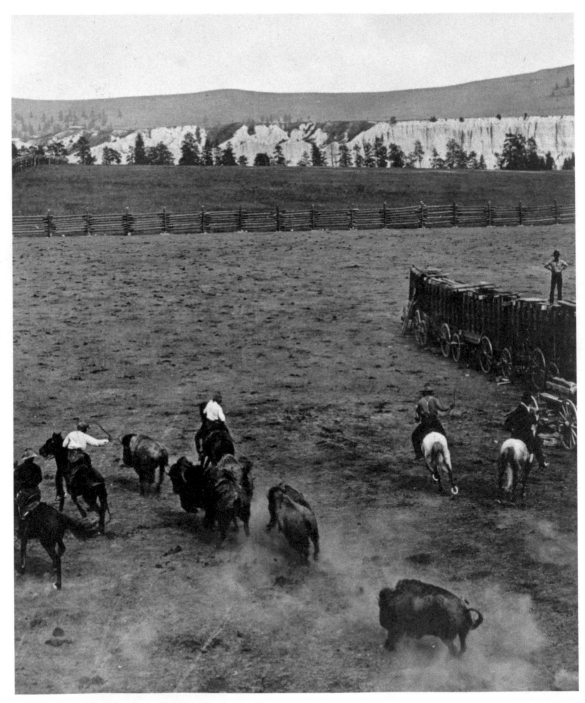

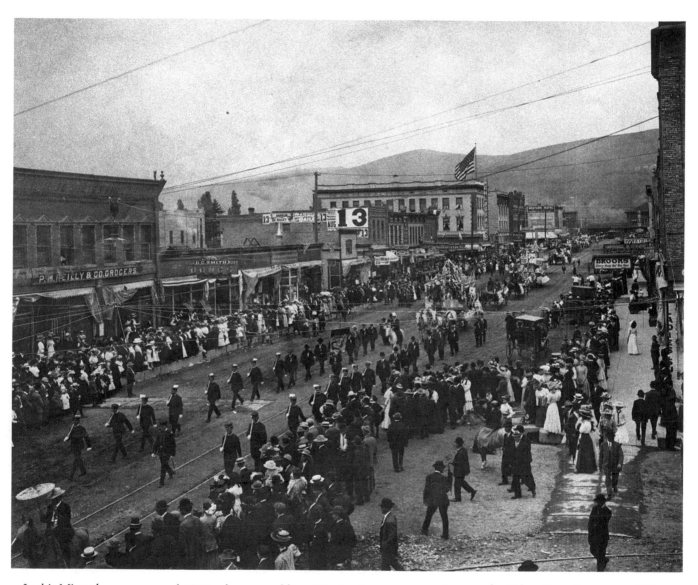

In this Missoula scene, around 1910, a large crowd lines Higgins Avenue as a parade passes by. Taken from the corner of Higgins and Broadway, the view is to the north. Smoke from Missoula's numerous lumber mills hangs behind the downtown buildings.

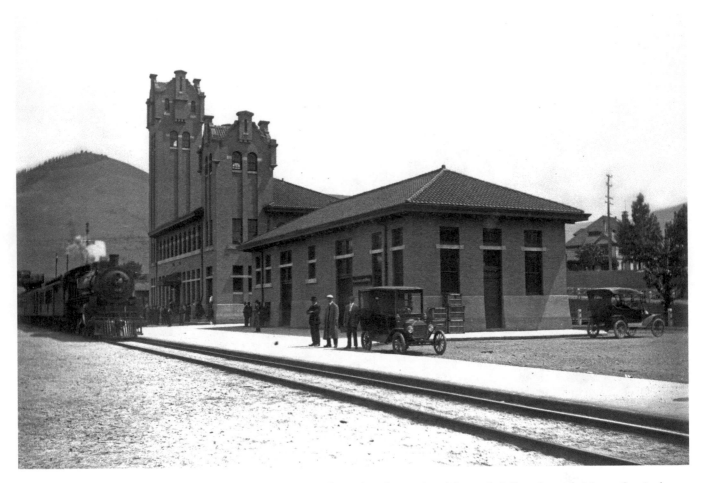

This well-composed photo shows a locomotive pulling into the Milwaukee Railroad Depot in Missoula, with Mount Sentinel rising in the background. The depot building was purchased and restored by the Boone and Crockett Club in the 1990s.

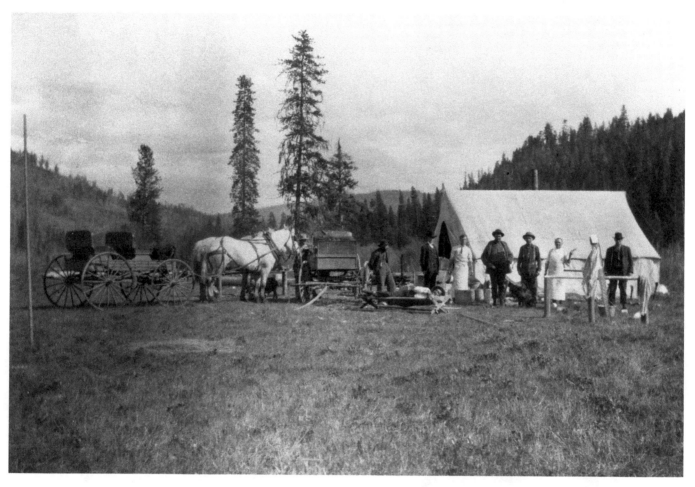

Cooks, teamsters, a U.S. Forest Service employee, and two foremen pose in front of a logging camp on Morell Flat, near Seeley Lake, in 1910. A carriage and a lunch wagon wait nearby. Massive forest fires swept the Northern Rockies in 1910, the year this photo was taken.

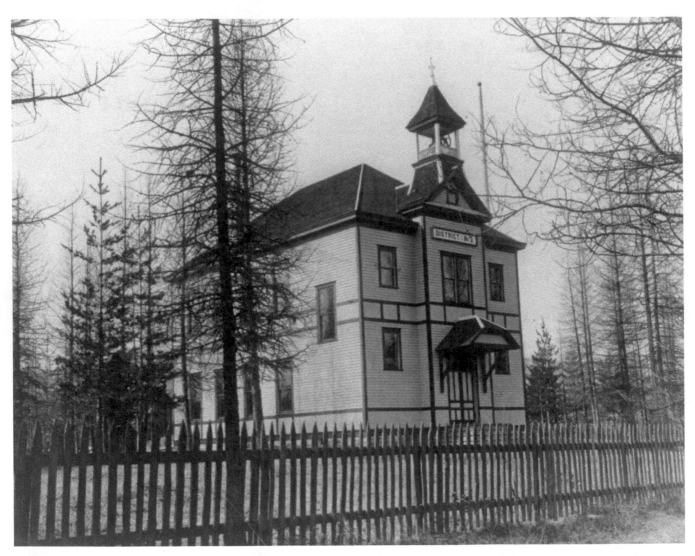

Seen here around 1910, the Heron School (District No. 3) is located just east of Heron in northwestern Montana. A logging community, Heron depended for its economy on the large cedar trees located nearby. The school is now a community center, home to the local library and the Heron Players theatrical troupe.

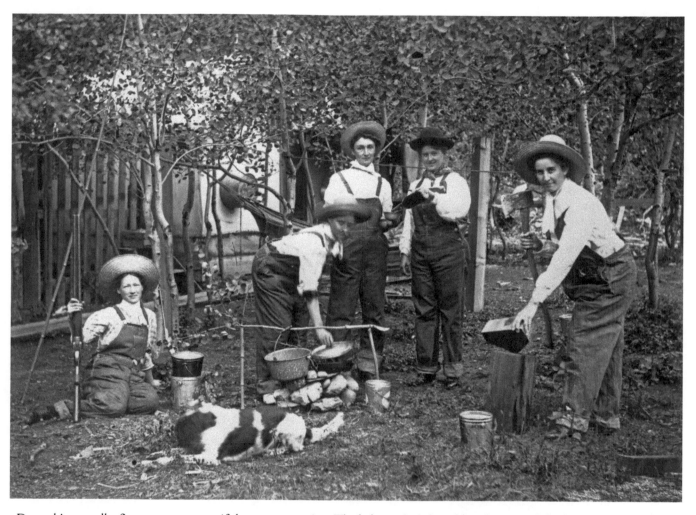

Dressed in overalls, five women pose as if they were camping. The lady on the left wields a shotgun while the one on the right has an ax. This photo was taken around 1910, probably in or near Bonner.

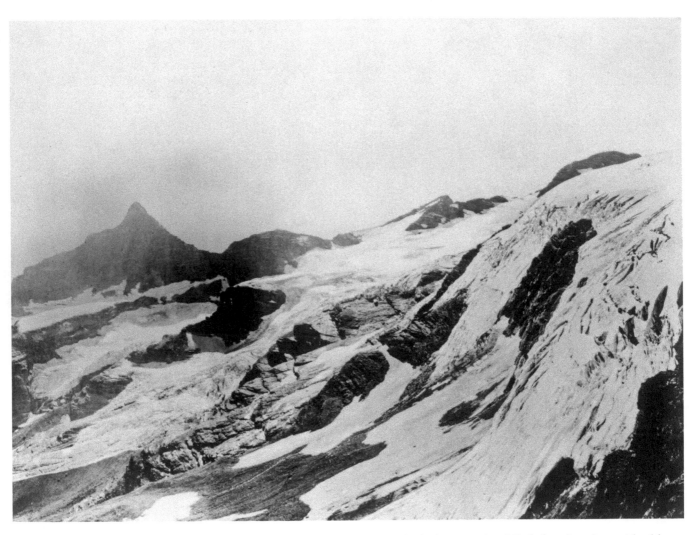

Harrison Glacier, viewed from the Continental Divide near the southern end of Glacier National Park, has shrunk considerably since this photo was taken in 1913. Scientists estimate that all of the park's glaciers will melt away by 2035.

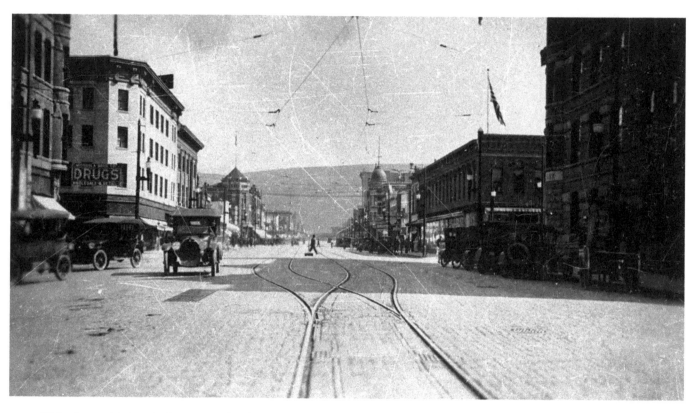

This photo of Missoula focuses on the electric trolley tracks on Higgins Avenue. Every major city in Montana had an electric trolley system in the early years of the twentieth century, but they lost popularity with the rise of ownership of private autos.

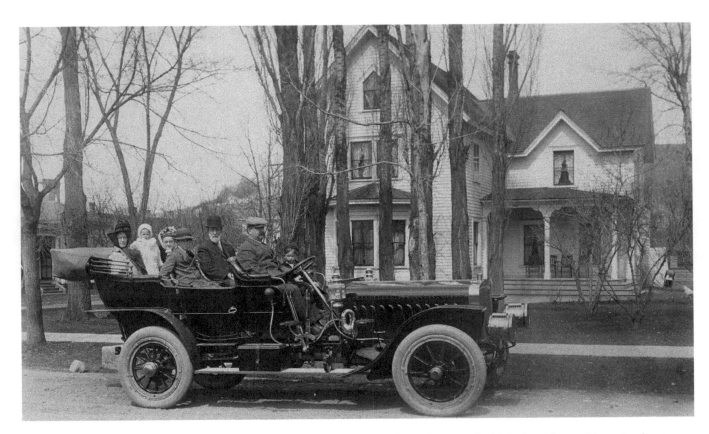

A loaded passenger car sits in front of the F. L. Worden House in Missoula. Built in 1874, this is the oldest residence in the city and is listed on the National Register of Historic Places. Worden's family owned the home for portions of three centuries. It is now a gift shop.

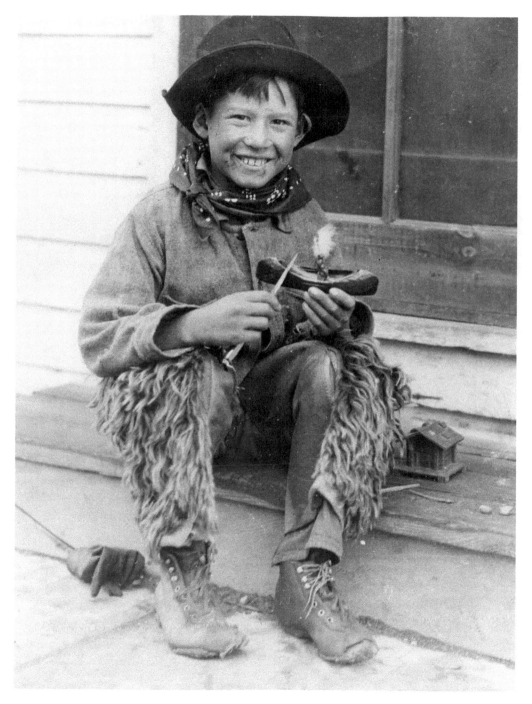

A young Eagle Aims Back skillfully carves a toy canoe on the Blackfeet Indian Reservation.

Missoula carpenter John Dunn spent much of his leisure time as an avid amateur photographer. Two of his favorite subjects were wife Edith and son Jack, both seen here around 1912. Dunn helped build Main Hall at the University of Montana and many of the university-area homes.

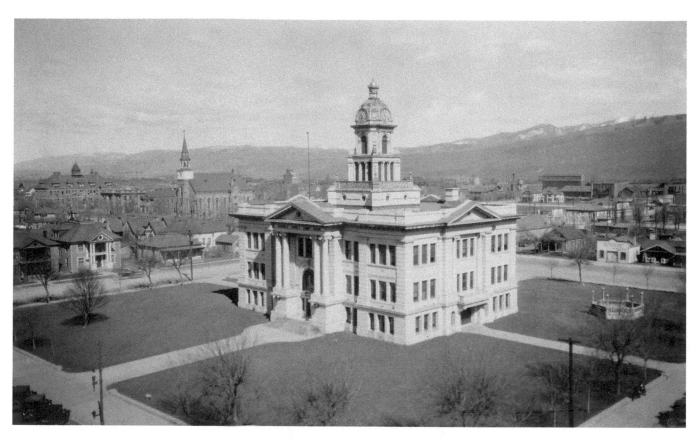

In 1908 architect A. J. Gibson was hired to design a new courthouse for Missoula County. This was a controversial decision, since Gibson was both an alderman and friends with members of the County Commission. Artist E. S. Paxson painted the eight murals that hang inside the building.

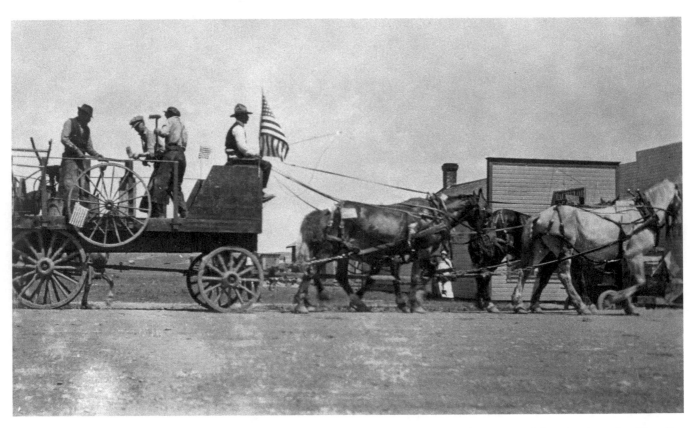

Patriotism was on full display during the Fourth of July 1916 festivities in Winnett, which was named for a local rancher. The oil boomtown became the seat of newly formed Petroleum County in 1925, but a fire four years later destroyed much of the business district of the town.

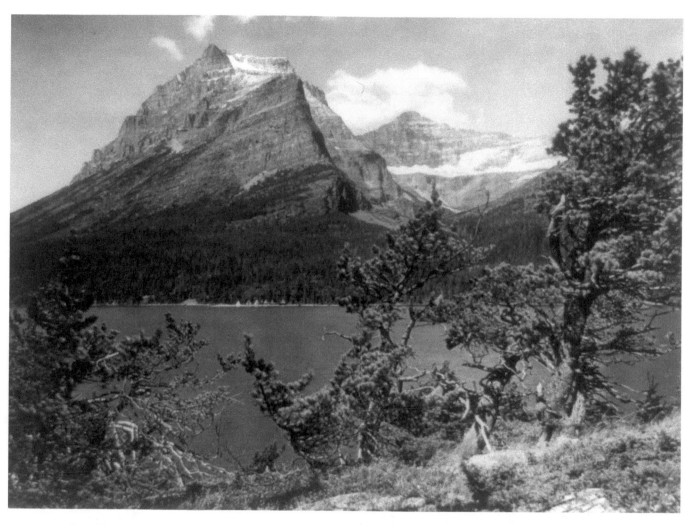

Author George B. Grinnell is considered the father of Glacier National Park. In 1901 he wrote, "Far away in northwestern Montana, hidden from view by clustering mountain-peaks, lies an unmapped counter—the Crown of the Continent." This view of the park around 1917 shows Going-to-the-Sun Mountain.

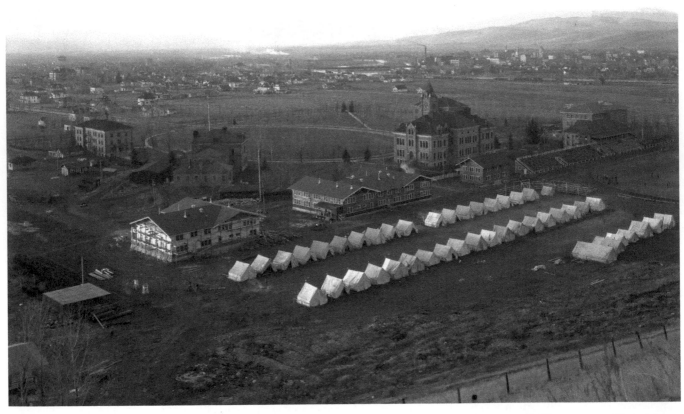

During World War I, the University of Montana campus hosted an Army camp just east of Main Hall. The Montana National Guard was mustered into federal service on April 7, 1917, and was ultimately designated the 163rd Infantry Regiment, of the 41st Division.

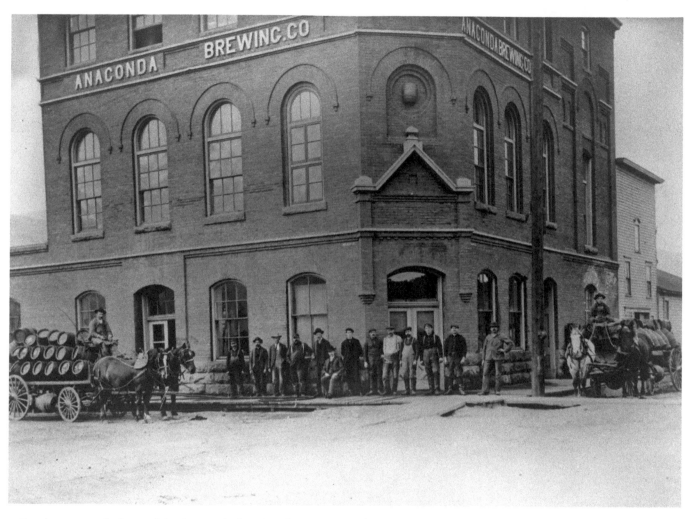

Employees pose in front of the Anaconda Brewing Company at Walnut and West Fourth streets around 1914. In addition to the brewery, the building had a saloon, a beer garden, and a bowling alley. Prohibition closed the brewery in 1918, and the company switched to producing soda until Prohibition was lifted.

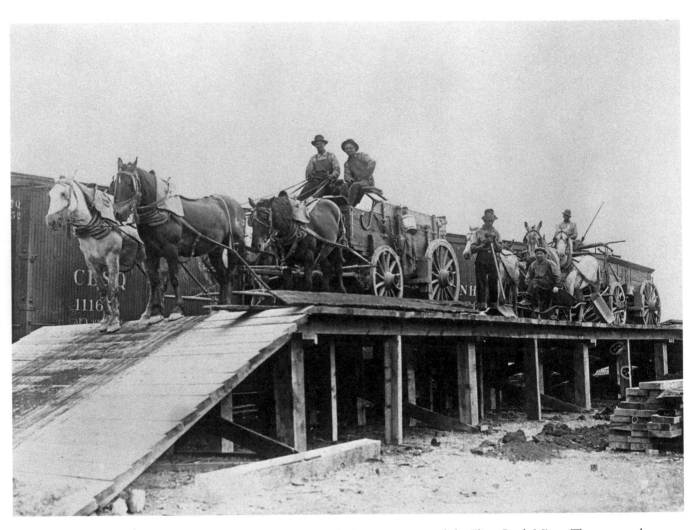

Teamsters unload manganese ore at Philipsburg, the town that had grown up around the Flint Creek Mines. The area was best known for its silver mines but also had some of the richest manganese ore found in the United States, as well as outcrops of lead and zinc.

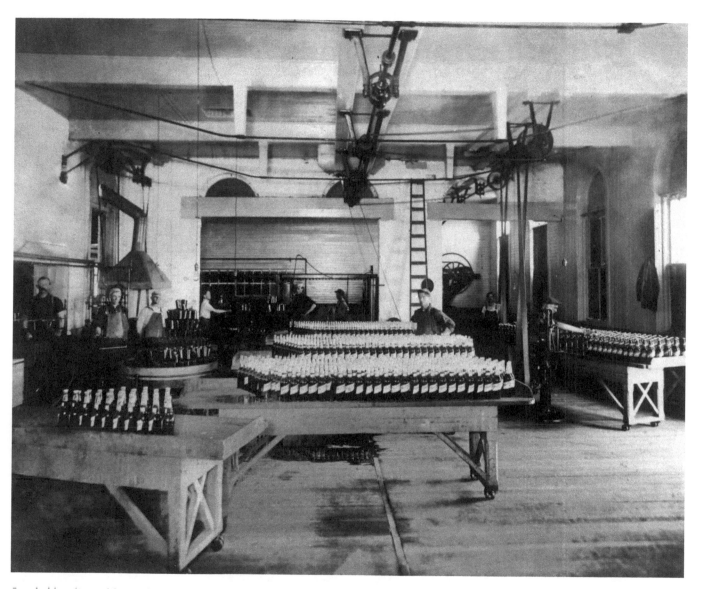

Loaded bottling tables at the Billings Brewing Company. This photo was taken in 1918, when the enactment of Prohibition in the state forced the company to dump hundreds of gallons of beer. During Prohibition, Tip Top Soda was produced in this facility.

George B. Grinnell stands on Grinnell Glacier in 1920. The prominent editor of *Forest and Stream* magazine, Grinnell was a founding member of the Audubon Society and the Boone and Crockett Club, and was instrumental in the protection of Glacier National Park.

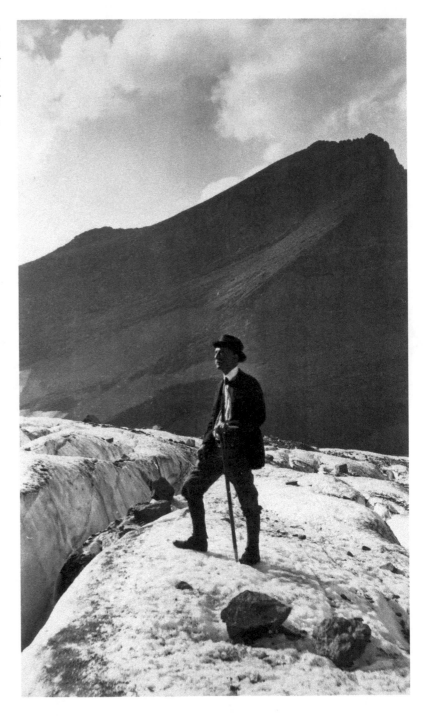

A Time of Drought and Depression

(1920–1939)

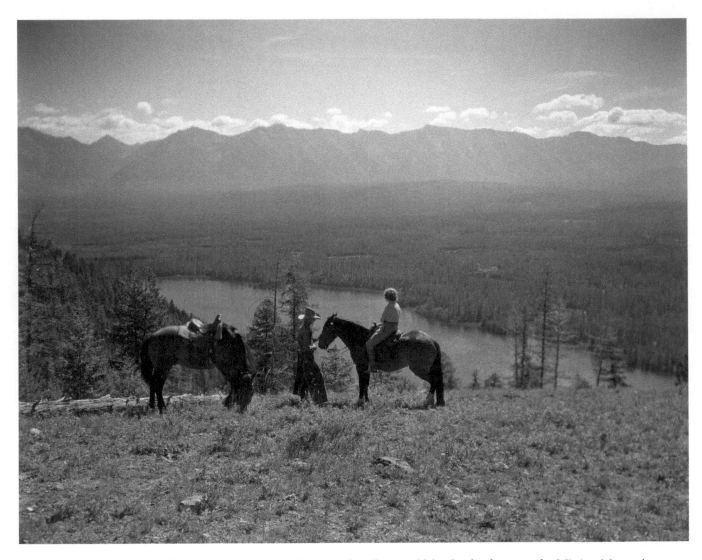

Horseback riders gaze toward Lindbergh Lake, a six-mile-long, glacially carved lake that lies between the Mission Mountains and the Swan Range. The Swan River flows north from Lindbergh Lake some 70 miles before it empties into Flathead Lake near Bigfork.

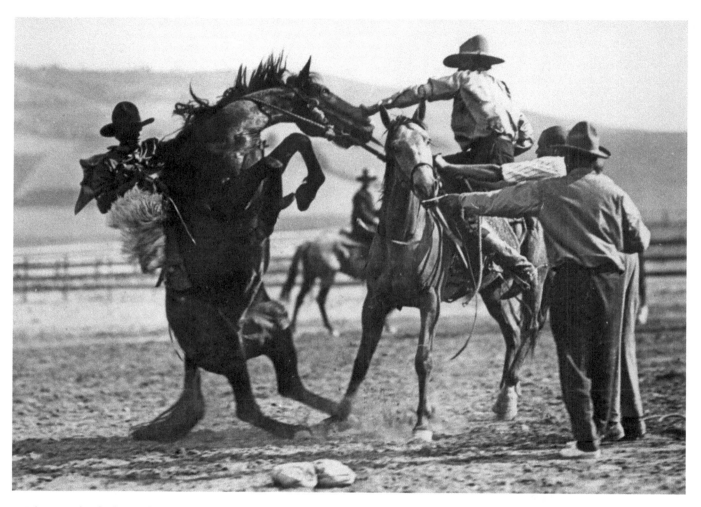

A bronc rider finds trouble at the Missoula stampede. A pickup man on horseback tries to control the bronco, while others circle nearby, waiting for a chance to help. The Missoula Stampede was one of the largest western shows in the United States and was often held on the Fourth of July.

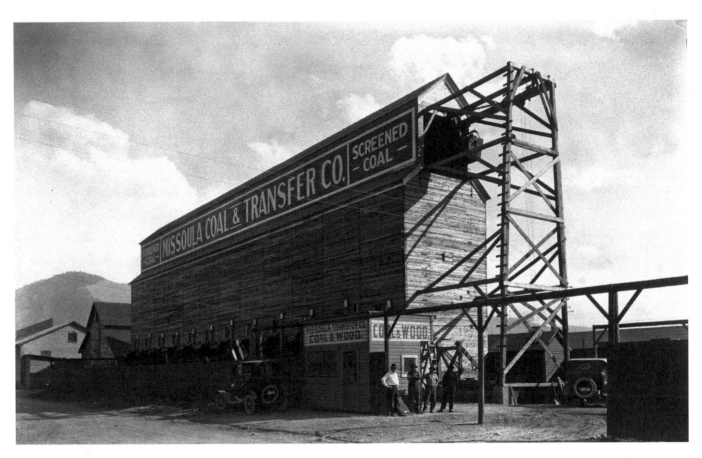

Coal was an important source of heat in many communities, and Montana had the largest coal reserves in the nation. This photo taken by R. H. McKay shows the Missoula Coal and Transfer Company during the 1920s. The company also sold firewood.

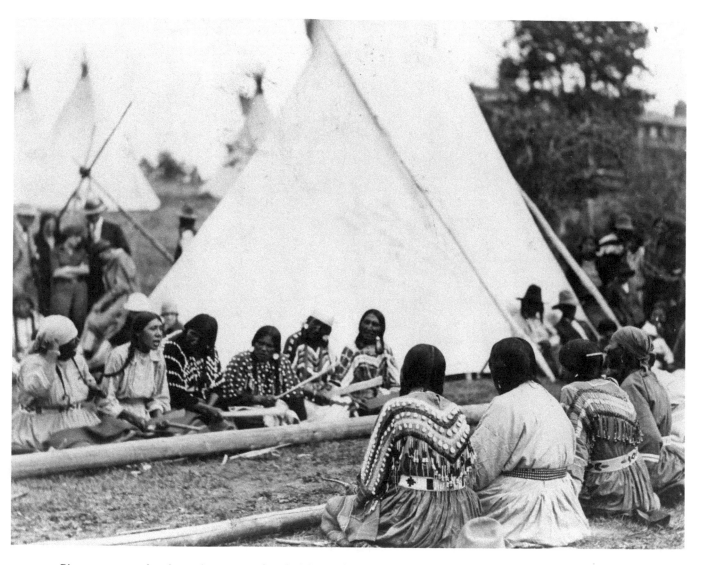

Piegan women play the stick game on the Blackfeet Indian Reservation. The stick game was very popular among many of the Plains Indian tribes. The Piegans are the southern branch of the Blackfeet tribe, with a reservation adjacent to Glacier National Park.

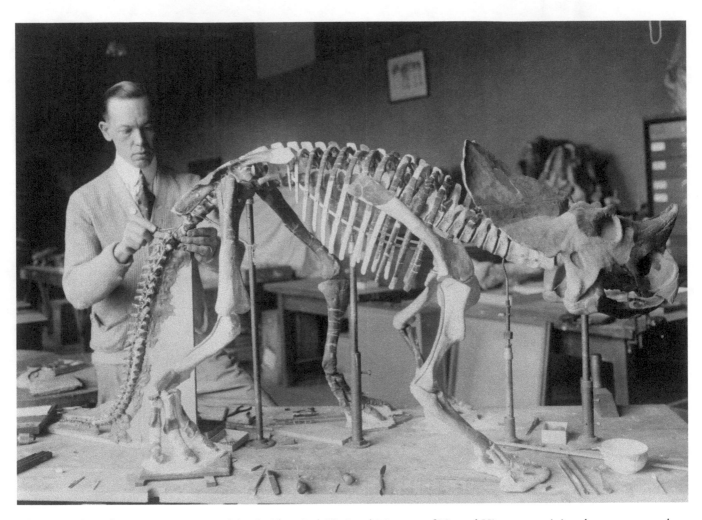

This 1921 photo depicts Norman Ross of the Smithsonian's National Museum of Natural History examining the reconstructed skeleton of a small dinosaur found in Montana. The fossilized skeletons of numerous dinosaurs, along with nests and fossilized eggs, have been found in the state.

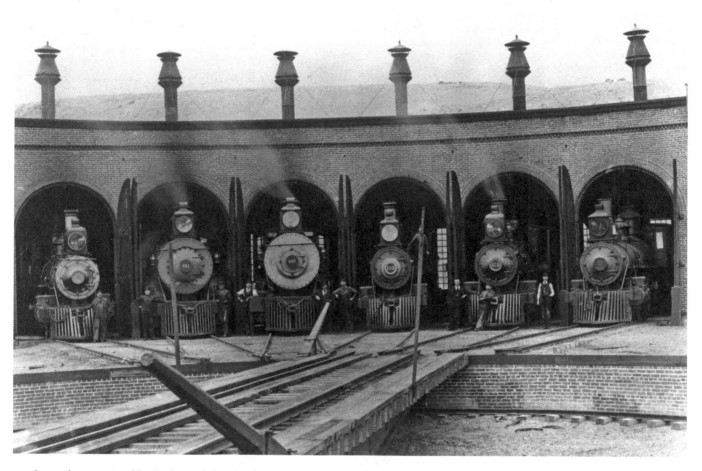

Steam locomotive fills the bays of the Northern Pacific Railway Roundhouse in Missoula, built in 1923. Beginning in the mid-1950s, the roundhouse would blow a whistle at 7:30 A.M. and 4:30 P.M. each day. The roundhouse and machine shops were torn down after the interstate highway was built in the mid-1960s.

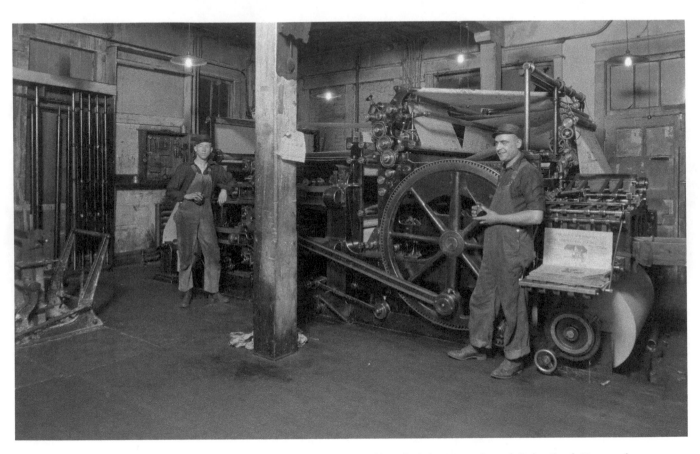

The pressroom of the *Daily Missoulian* is shown here in 1923. Originally called the *Missoula and Cedar Creek Pioneer,* the newspaper has been published continuously since 1870. The Anaconda Copper Mining Company owned the *Missoulian* (and numerous other papers) for 42 years.

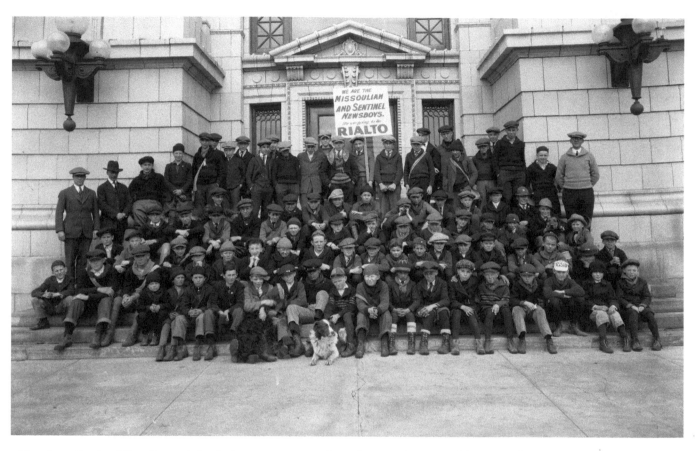

Newsboys for the *Missoulian* and *Sentinel* newspapers pose for a photo on the steps of the Missoula County Courthouse in 1923. These boys could be found hawking newspapers all over downtown, from the Northern Pacific Depot to the Higgins Bridge.

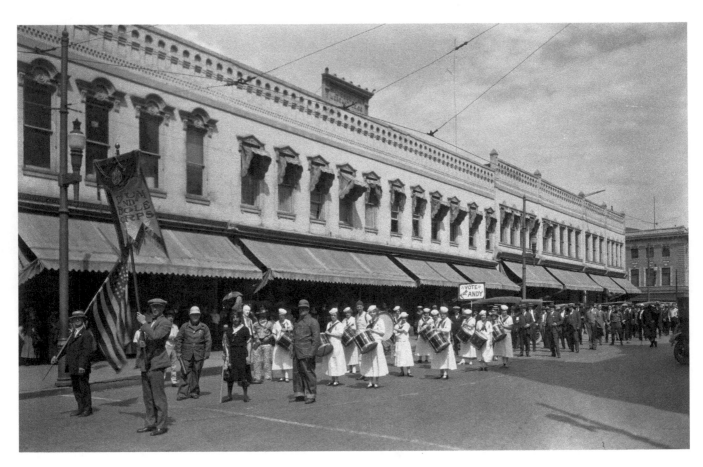

On the day of the annual Missoula Mercantile company picnic in 1924, employees parade past the company store on Higgins Avenue. Founded in 1865, the "Merc" is believed to be the oldest continuously operating retail store west of the Mississippi. It is now owned by Macy's.

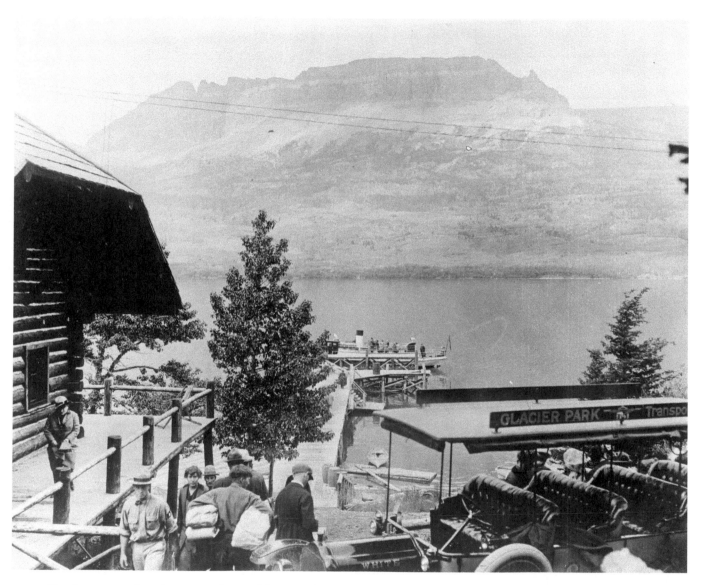

Tourists prepare for a boat tour of one of the many lakes in Glacier National Park. In the foreground sits a forerunner of the "jammers," the buses that ferried tourists over the spectacular roads of the park.

The New Mine Sapphire Syndicate was an English-owned company that mined high-quality Yogo sapphires from 1899 to 1927. Known for their unique color as well as their quality, Yogo sapphires are found along a five-mile-long dike of volcanic rock near Utica. The site was photographed in September 1924.

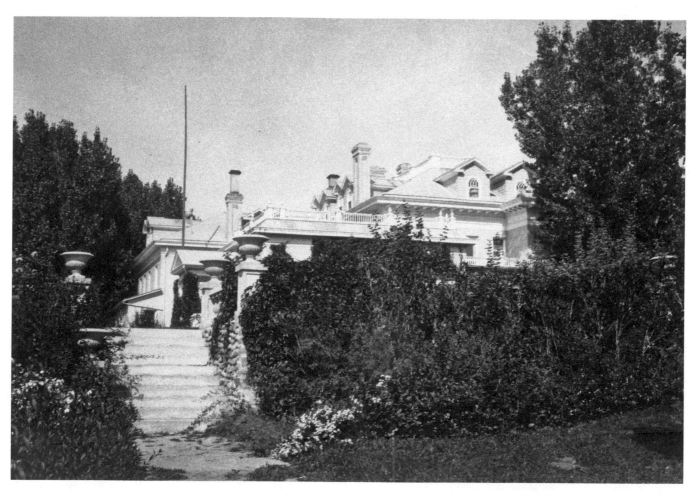

In 1886 copper king Marcus Daly bought a large stock farm near Hamilton. Over the next several decades he undertook an extensive remodeling of the existing farmhouse, and his widow continued with the improvements after Daly's death in 1900. The Daly Mansion, seen here in 1925, is now owned by the state of Montana.

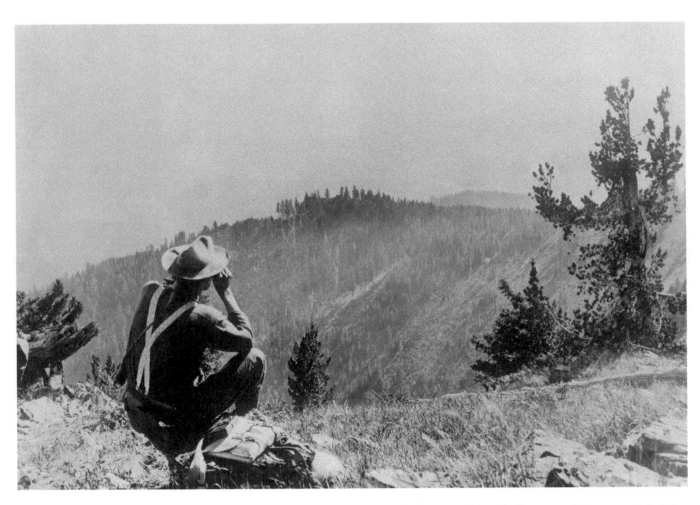

A U.S. Forest Service ranger scans the Clark Fork Valley from the heights of the Mount Silcox lookout, near Thompson Falls. The Bitterroot Range rises on the far side of the river.

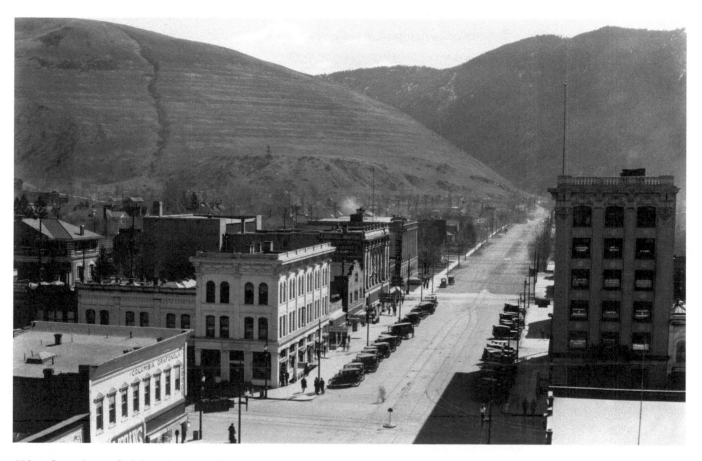

Taken from the roof of the Palace Hotel in Missoula around 1925, this photo shows East Broadway. In the background is Hellgate Canyon, so named because of the frequent Blackfeet ambushes on Salish and Nez Perce that once took place there. Mount Jumbo is on the left, with Mount Sentinel on the right.

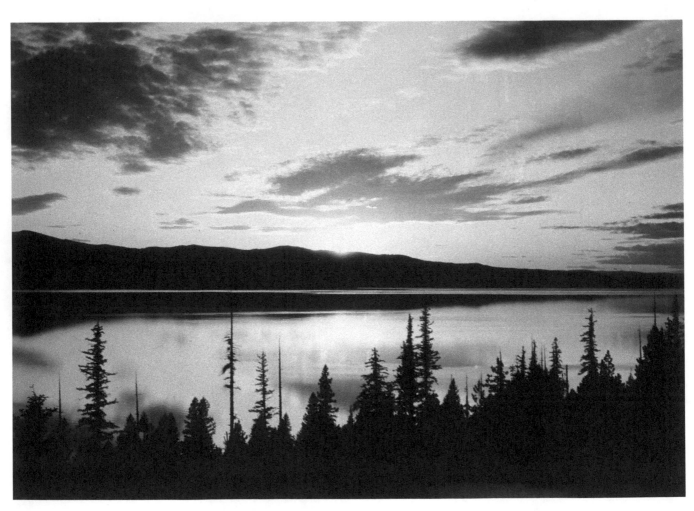

R. H. McKay took this photo of a spectacular sunset over Flathead Lake as viewed from the east shore in June 1927.

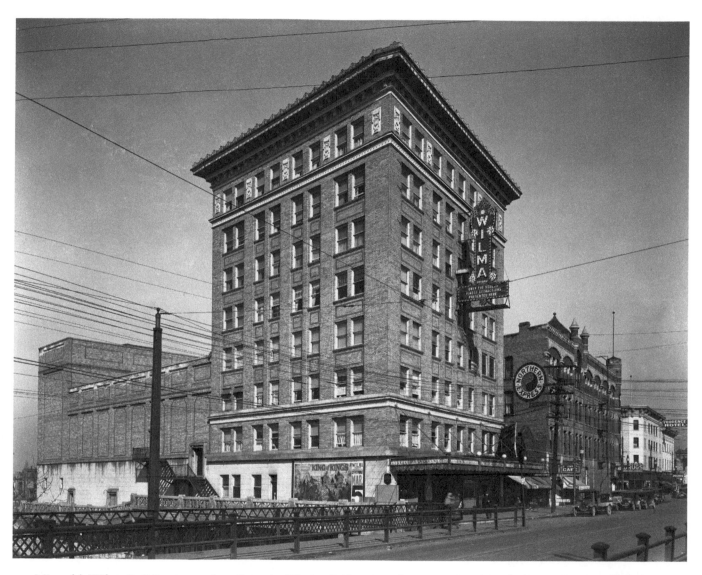

Missoula's Wilma Building is seen here from the Higgins Bridge. At eight stories, the Wilma was the tallest building in western Montana in the 1920s. Besides housing a theater, the building boasted an Olympic-size swimming pool, a restaurant, shops, a dozen apartments, and 50 offices.

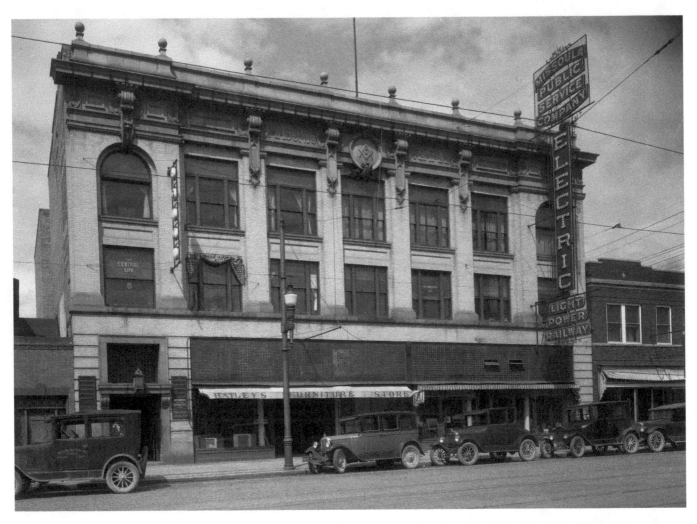

Missoula's ornate Masonic Temple on Broadway was built in 1909 and is seen here in 1928. Beginning in the 1860s, Masons worked the bring law and order and a sense of community to Montana's rough-and-tumble mining camps. The Missoula Public Service Electric Company was once housed in this building.

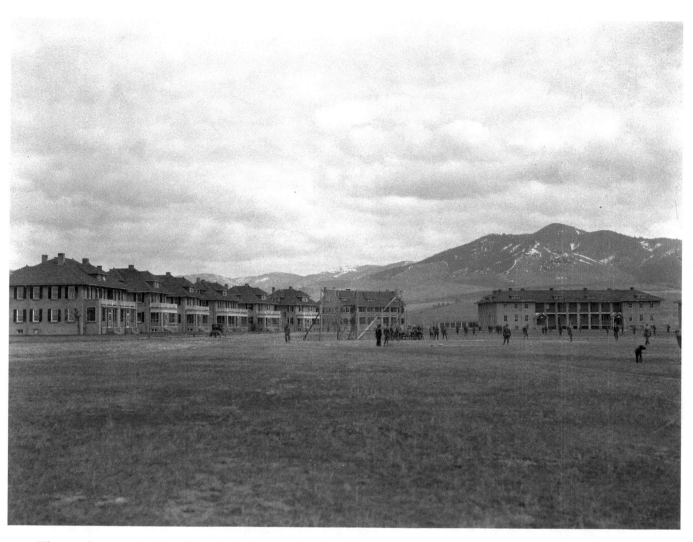

The parade grounds at Fort Missoula doubled as a baseball field in this October 1931 view. Officer's Row is at left, while one of the enlisted men's barracks buildings is at right. Mount Dean Stone rises in the background. Officer's Row is now home to various nonprofit groups.

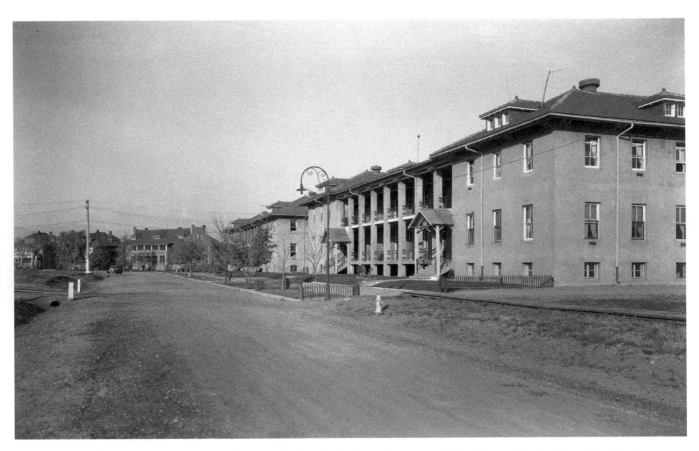

This 1931 view of the enlisted men's barracks at Fort Missoula looks north toward Officer's Row. During the 1930s the fort was home to a battalion of the 4th Infantry Regiment and also served as regional headquarters of the Civilian Conservation Corps.

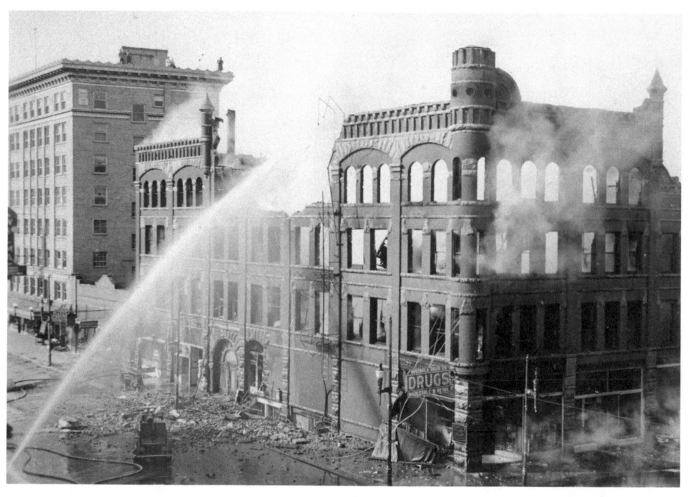

The castlelike Hammond Building in Missoula was destroyed by fire in 1932. The building served as headquarters for Andrew Hammond, a business rival of Marcus Daly and C. P. Higgins. Hammond built the nation's largest sawmill at Bonner and controlled the Missoula Mercantile, the Hotel Florence, and the First National Bank.

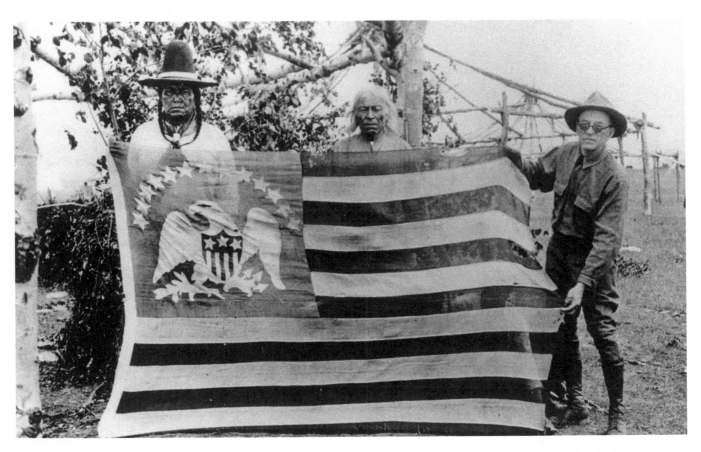

Loud Thunder (Jim Gopher), at center, displays the antique flag bearing the 13 stars of the original colonies that had been passed down through generations of his family. Frank B. Linderman, author of the book *Indian Why Stories,* stands at right in this 1933 photograph.

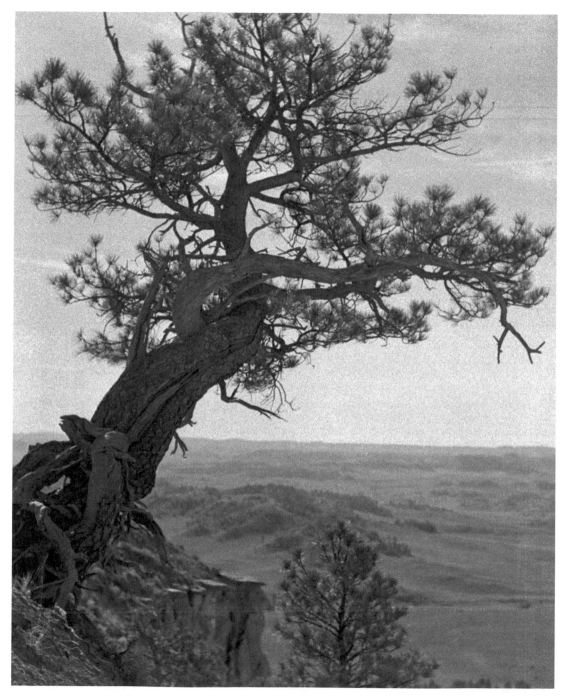

A twisted pine stands sentinel over the Beaver Creek area of the Custer National Forest in this 1934 image by the prolific photographer Kenneth D. Swan. Swan worked for the U. S. Forest Service and was instrumental in convincing the general public of the beauty and value of national forests.

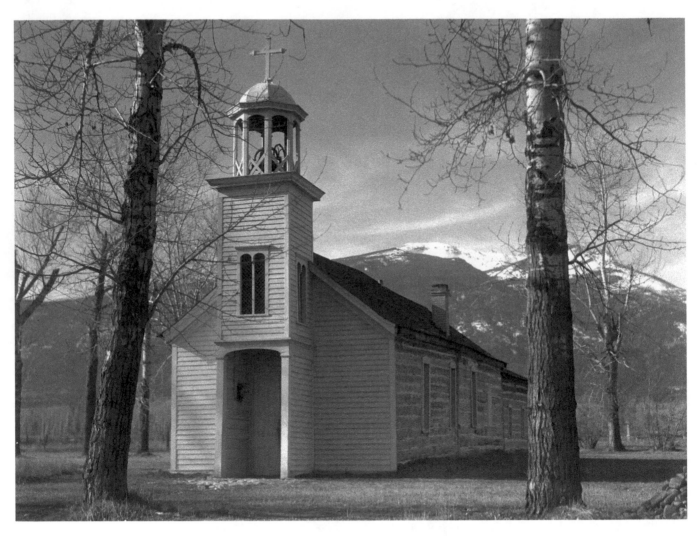

At the request of the Salish Indians, Father DeSmet and other Jesuits arrived in the Bitterroot Valley in 1841 and began construction on St. Mary's Mission. Stevensville, the state's first town, grew up around the mission. This view is from 1934.

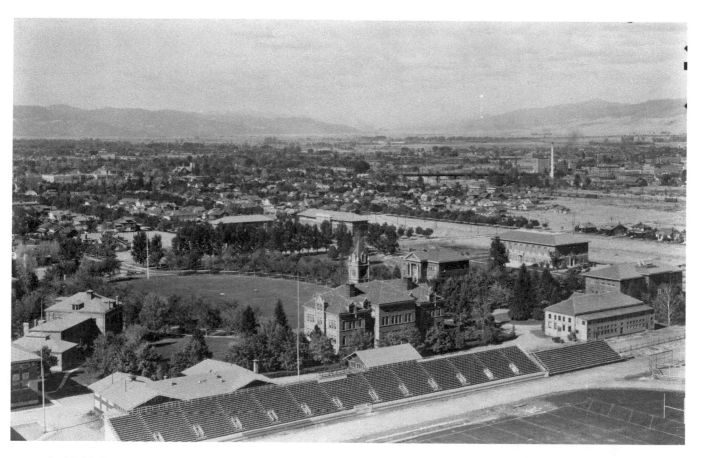

R. H. McKay snapped this photo of Missoula from Mount Sentinel in 1936. The University of Montana campus sits in the foreground. The Mansfield Library and University Center have since replaced the sports stadium seen here.

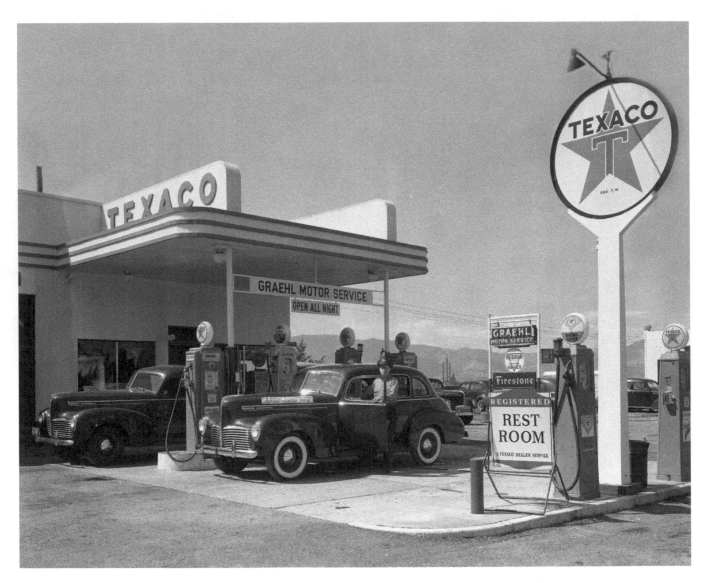

The Graehl Motor Service Texaco station in Missoula sold Hudson automobiles as well as gasoline. After the first Texaco station opened in 1911, the brand spread quickly across the country, with standardized signs, brochures, and advertisements.

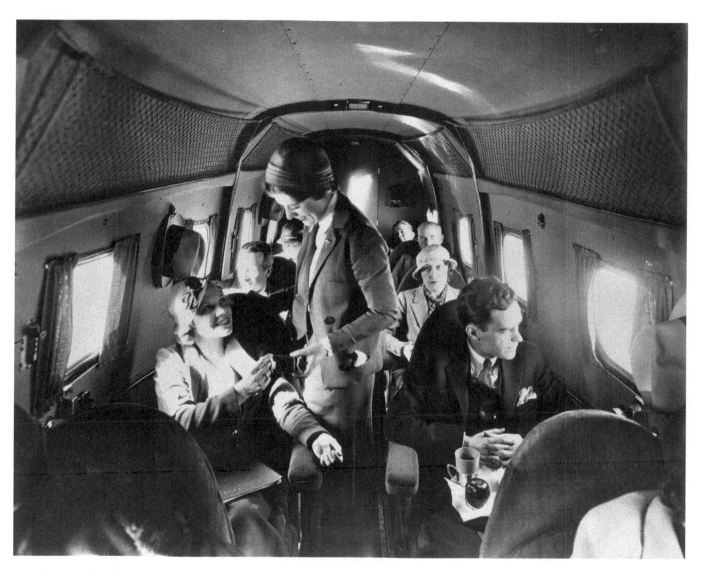

Northwest Airlines began regular service to Billings, Glendive, Miles City, Helena, Butte, and Missoula in 1933. This 1936 photo shows passengers aboard an early airliner at the Missoula airport.

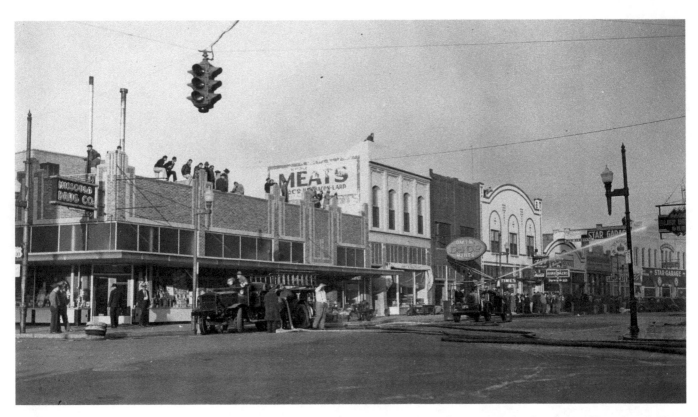

A Missoula crowd gathers at the corner of Higgins and Front streets to watch fire fighters attack the flames engulfing the Hotel Florence on September 26, 1936. The building was reduced to a hold filled with blackened rubble and remained so for a number of years. The Florence had burned once before, in 1912.

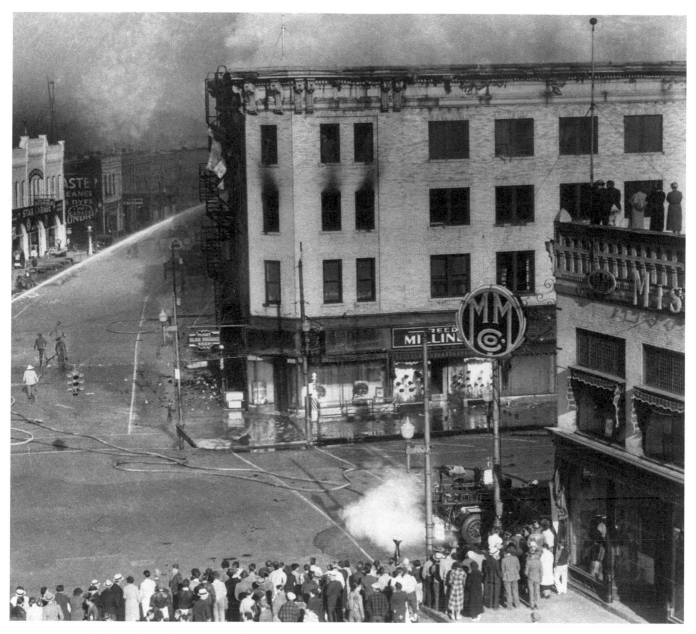

A crowd of onlookers gives the firefighters room to work as they battle unsuccessfully to save the Hotel Florence. Five years after the 1936 fire, a new Hotel Florence was erected on the same site with financial backing from the owners of the Missoula Mercantile, located across the street.

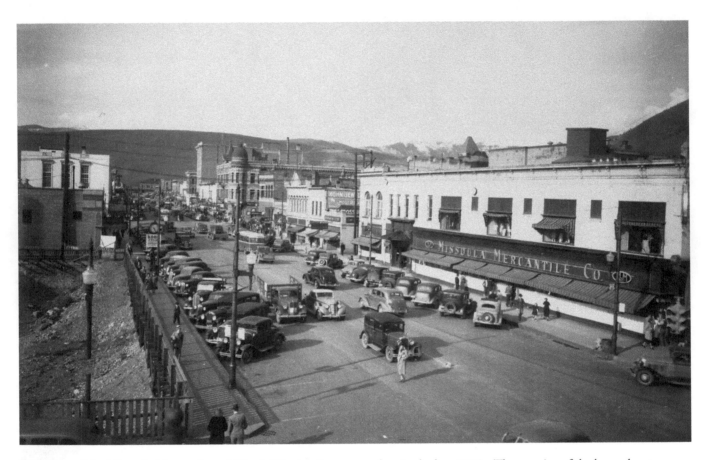

This view of the Missoula Mercantile and North Higgins Street was taken in the late 1930s. The remains of the burned-out Hotel Florence can be seen at left. W. H. McLeod of the Missoula Mercantile led a public fund-raising campaign to replace the Hotel Florence.

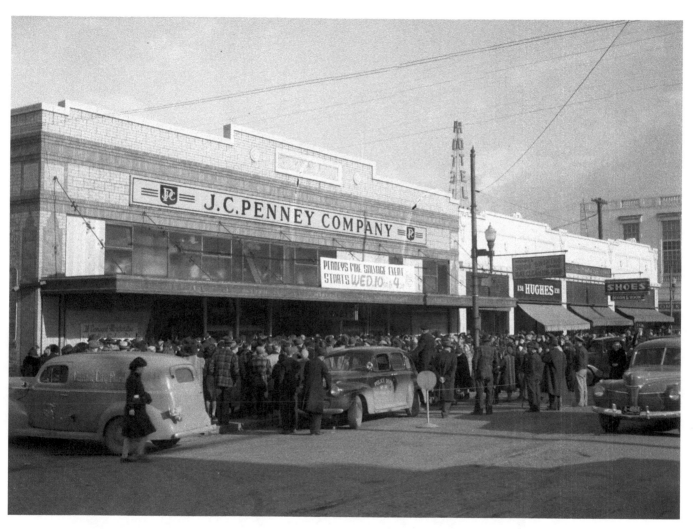

A crowd gathers outside the J. C. Penney Company store on North Higgins in Missoula. The company started in 1902 with a single store in Wyoming, called the Golden Rule, and quickly expanded to include hundreds more. A 1950 fire cause $100,000 in damage to this building.

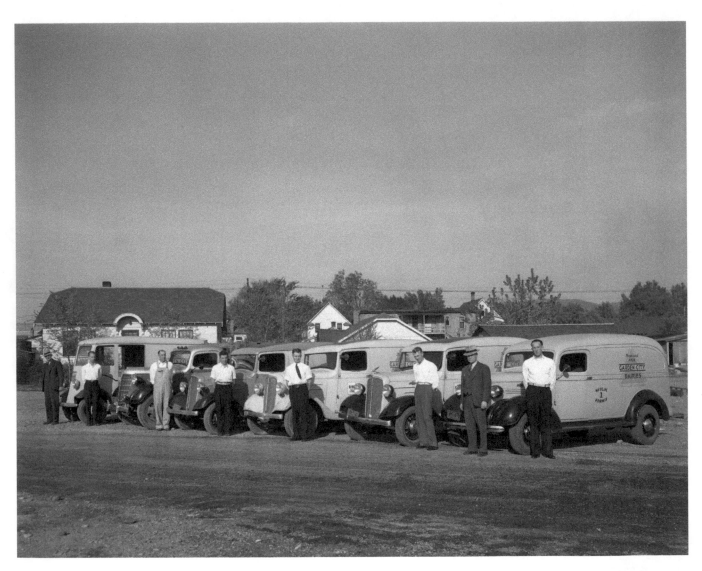

Delivery drivers for the Garden City Dairies pose before their fleet of milk trucks. These drivers were out before dawn each morning, delivering bottles of milk to nearly every household in Missoula.

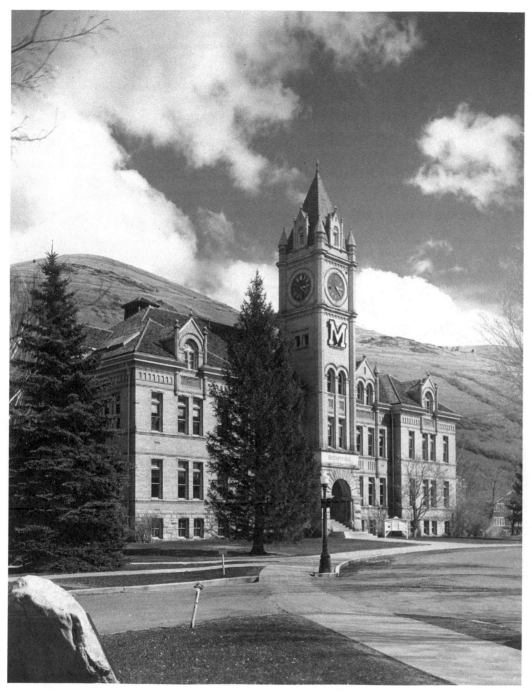

Noted architect A. J. Gibson designed the University of Montana's University Hall. Now known as Main Hall, it was the first building constructed on the Missoula campus. Taken 39 years after its construction in 1898, this photo shows the passage of time in the size of the trees.

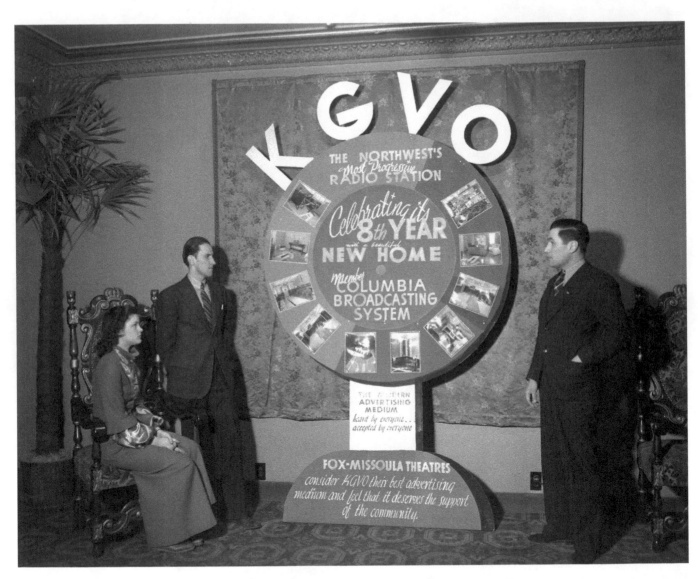

A display in the lobby of Missoula's Fox Theatre promotes KGVO, the "Northwest's Most Progressive Radio Station." The station was celebrating its eighth year as a member of the Columbia Broadcasting System, having started in 1931. KGVO radio is still on the air more than 75 years later.

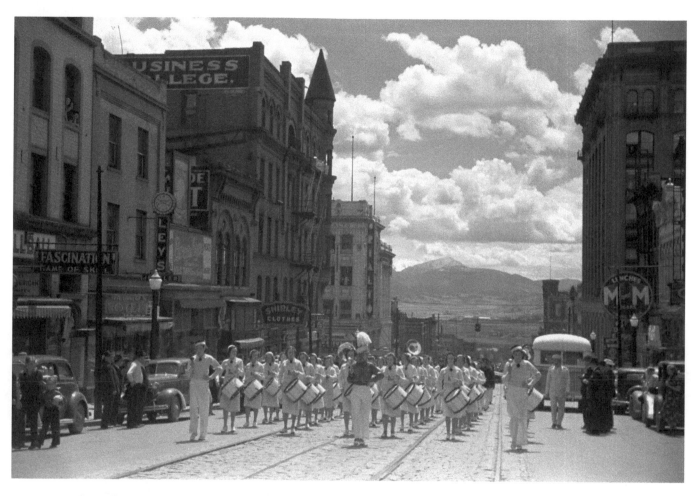

Using the trolley tracks for guidance, a high school band marches down Butte's Main Street in 1939. At right sits the famous M&M Cigar Store. After visiting it, the beat writer Jack Kerouac described the experience as "the end of my quest for an ideal bar."

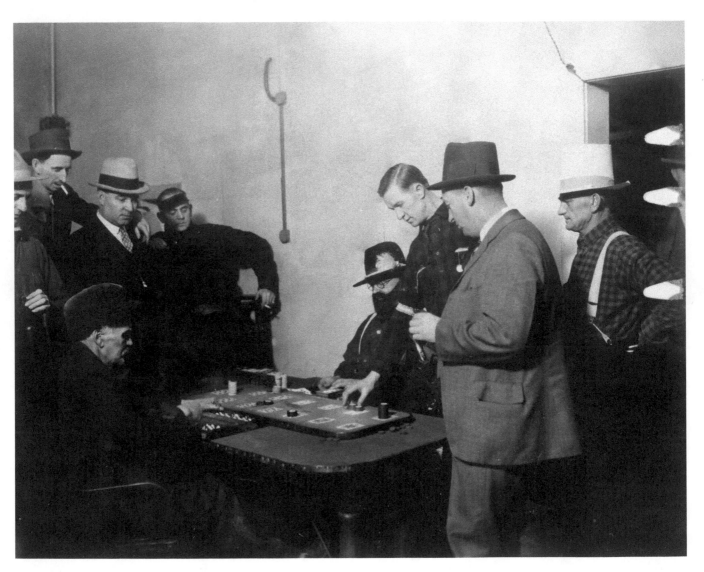

Gambling was declared illegal in Montana in 1889, but games of chance reappeared after the repeal of Prohibition in 1933. The state legislature legalized many table games in 1937 with passage of the Hickey Act. This photo was probably taken in Billings.

Pearl Harbor and WWII

(1940–1944)

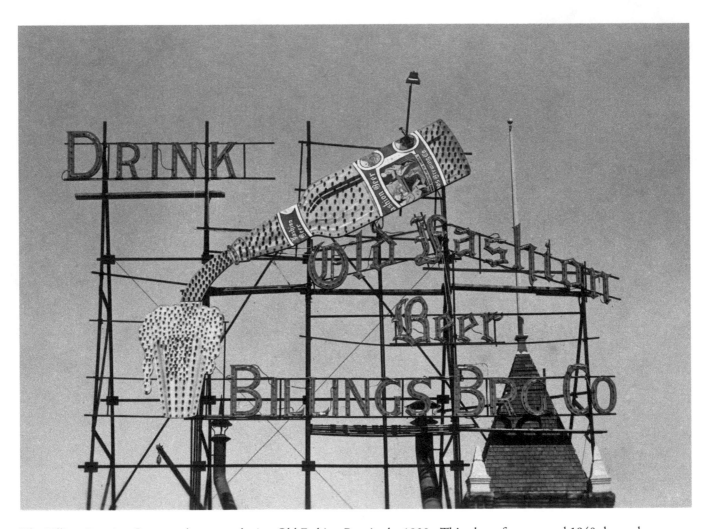

The Billings Brewing Company began producing Old Fashion Beer in the 1930s. This photo from around 1940 shows the company's roof-mounted electric sign. The brewery dropped the Old Fashion brand in the 1950s and replaced it with Tap Beer in cans. The brewery closed in 1952.

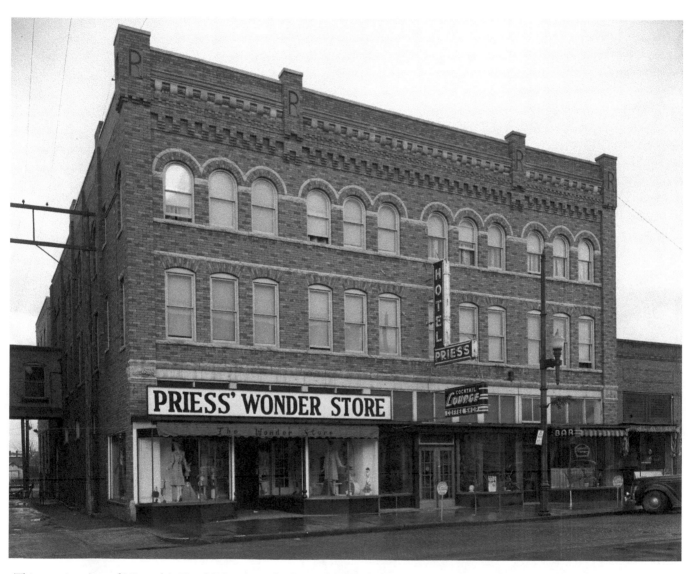

This exterior view of Missoula's Hotel Priess in 1940 shows the Wonder Store on the ground floor, along with the coffee shop and cocktail lounge. The hotel burned in 1972, killing a man named Robert Harvey Longabaugh who claimed to be the son of the Sundance Kid.

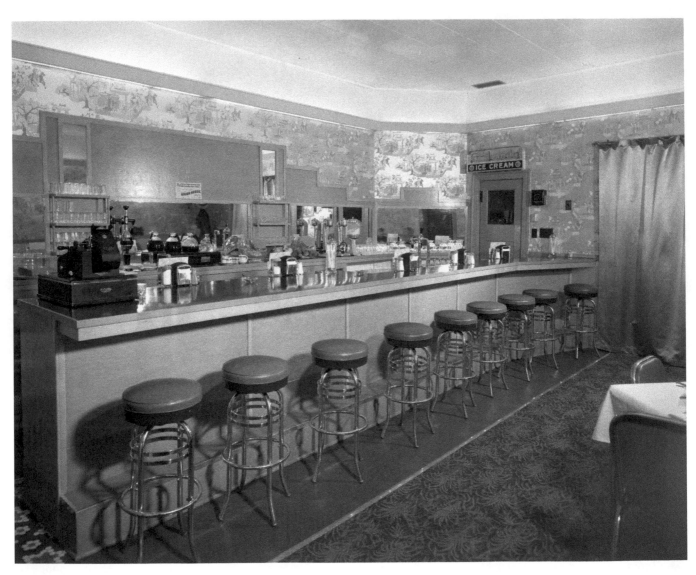

The coffee shop in the Hotel Priess featured modern decor and a typical lunch counter of the day.

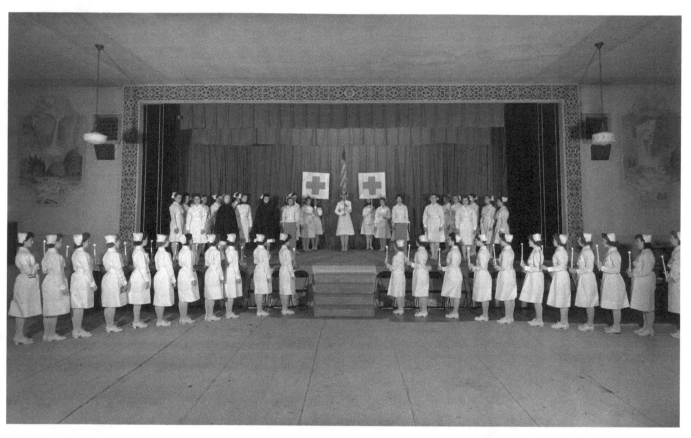

World War II had a profound effect on every aspect of life in Montana. In this 1942 photo by Missoula's R. H. McKay, uniformed nurses attend a Red Cross event in a ballroom. The American Red Cross enlisted more than 100,000 nurses for military service during World War II.

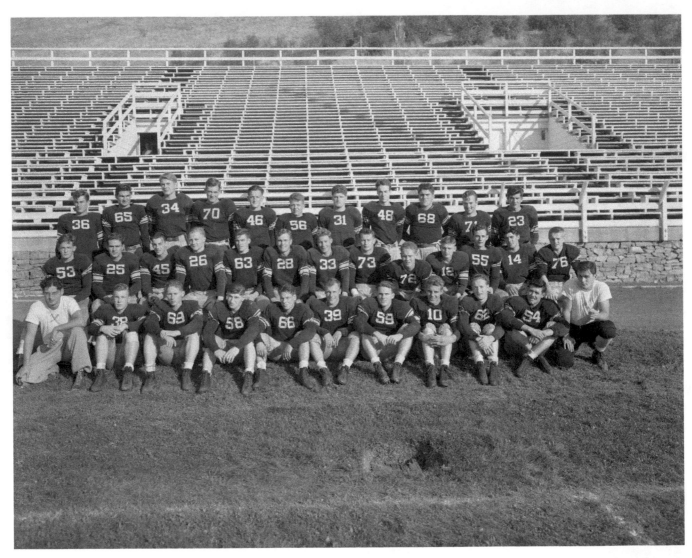

The University of Montana freshman football team poses for a photo in October 1942. The varsity team won zero games that season. The 1943 and 1944 football seasons were canceled due to the war.

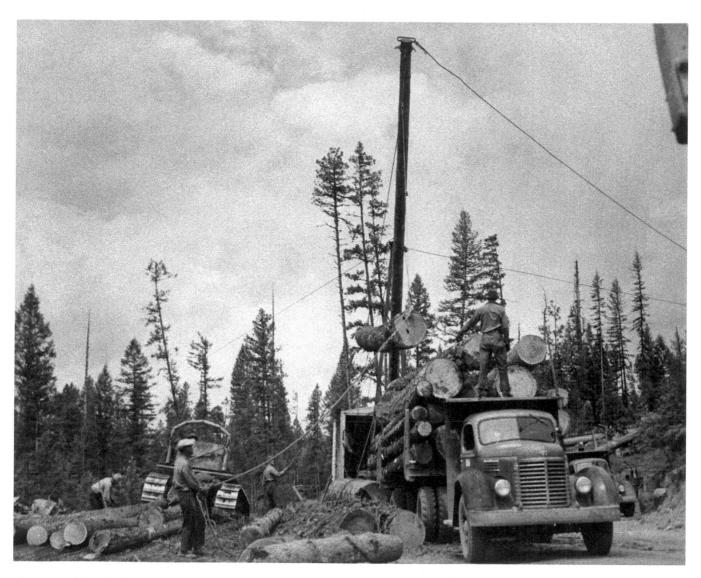

A crew working for the Anaconda Company load logs near Woodworth, just east of Salmon Lake, in 1943. World War II brought a boom in demand for wood products, along with a serious labor shortage. Anaconda owned significant land in the Blackfoot and Clearwater drainages.

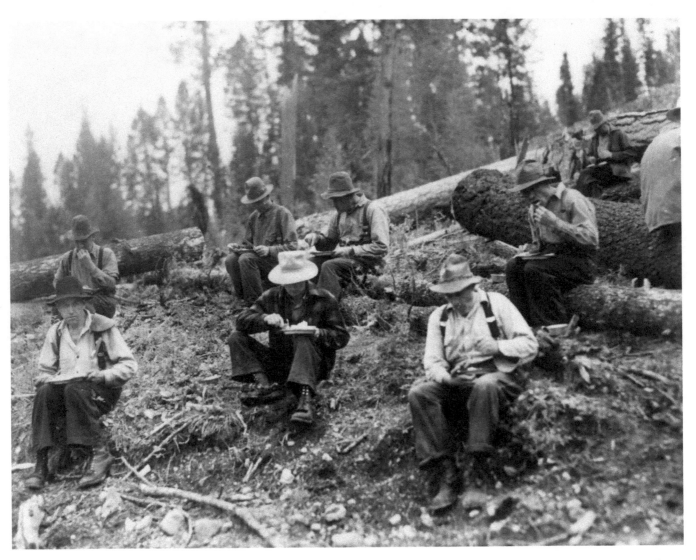

Loggers break for a hot lunch near Woodworth. Logs were loaded onto the Big Blackfoot Railroad and carried to the Anaconda Company sawmill in Bonner. Loggers had been working this same area for almost 50 years when this photo was taken in 1943.

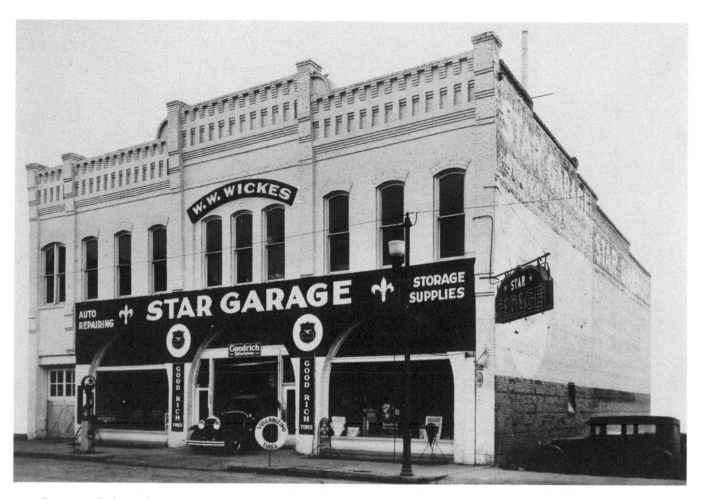

Conveniently located on West Front Street, the Star Garage was one of Missoula's larger service stations. When this photo was taken in 1944, rationing of gasoline and rubber tires was proving a hardship for citizens and businesses alike.

Notes on the Photographs

These notes, listed by page number, attempt to include all aspects known of the photographs. Each of the photographs is identified by the page number, a title or description, photographer and collection, archive, and call or box number when applicable. Although every attempt was made to collect all data, in some cases complete data may have been unavailable due to the age and condition of some of the photographs and records.

Printed in the USA
CPSIA information can be obtained
at www.ICGtesting.com
JSHW072022140824
68134JS00042B/3738